The Creative

Source Book

The Creative

Calligraphy

Source Book

Adrian Waddington

Watson-Guptill Publications/New York

First published in Great Britain in 1996
by Collins & Brown Ltd,
London House,
Great Eastern Wharf,
Parkgate Road,
London SW11 4NQ

First published in the United States in 1996 by Watson-Guptill Publications,
a division of BPI Communications, Inc., 1515 Broadway, New York, N.Y. 10036

Library of Congress Cataloging-in-Publication Data:
Waddington, Adrian.
 The creative calligraphy source book : choose from 50 imaginative
projects & 28 alphabets to create countless successful designs /
Adrian Waddington.
 p. cm.
 Includes index.
 ISBN 0-8230-0554-2 (pbk.)
 1. Calligraphy. 2. Alphabets. I. Title
Z43.W14 1996
745.6'1--dc20 96-24294
 CIP

Editorial Director: Sarah Hoggett
Project Editor: Helen Douglas-Cooper
Designer: Adrian Waddington
Picture Research: Sara Waterson

Printed in Singapore

1 2 3 4 5 / 00 99 98 97 96

Contents

Introduction

Letters – their structure, form and overall shape – are fascinating. Each day we are surrounded by letters in many different forms – on such things as packaging, advertising hoardings and neon signs – and yet hardly ever do we give them a second glance. Every day we use a pen to write without stopping to think that passages of text, words and letters can be beautiful things in their own right.

Whether you are a beginner to calligraphy and drawing letterforms, or an experienced calligrapher, I hope that you will be inspired to use letters creatively, for uses and on objects that you may not previously have considered. Through trying the various techniques, in different mediums, you can achieve pleasing results and at the same time develop your calligraphic skills. The projects included in this book will introduce you to the fantastic versatility that letters and the variety of mediums available allow. Instead of covering a recipe, address or scrap book with images, why not give it character or personalize it with decorative lettering that relates to its contents? Alternatively, simple labels for various objects around the home are not just practical, they provide a very good reason to practise and improve your letterforms.

The book is divided into ten sections, each showing a different style of letterform, arranged in chronological order. In each section there is a brief explanation of how the letters were developed, followed by projects that use the letterforms creatively. Each section concludes with at least two whole alphabets, illustrating the order in which to make the strokes, heights of the letters and any particular points to note – all that is needed to construct each letter. Using these alphabets as a starting point, you will be able to draw a variety of different letterforms, and as your confidence grows, you should be able to adapt and develop your own forms. While the styles of some letterforms lend themselves more to certain types of projects than others, you can take letters from one section and use them for projects in another section. In the same way, the tip boxes throughout the book can be applied to whatever letterforms you are using. There are also materials and techniques sections at the front, which beginners will find useful.

Letters are the basis of the calligrapher's art. Since the first alphabet was designed in the time of the Roman Empire, and through the work of scribes during the Dark and Middle Ages, distinct styles have emerged at different times in history, from the well-proportioned, open forms of the Caroline alphabet to the heavy, angular forms of Black Letter. Since the advent of printing, calligraphers and type designers have continued to develop letterforms in styles that reflect their time, and have expanded the uses to which lettering can be put and the types of materials with and on which it can be produced. This diverse heritage of lettering styles provides a rich source of inspiration for contemporary calligraphy, for both practical and decorative objects.

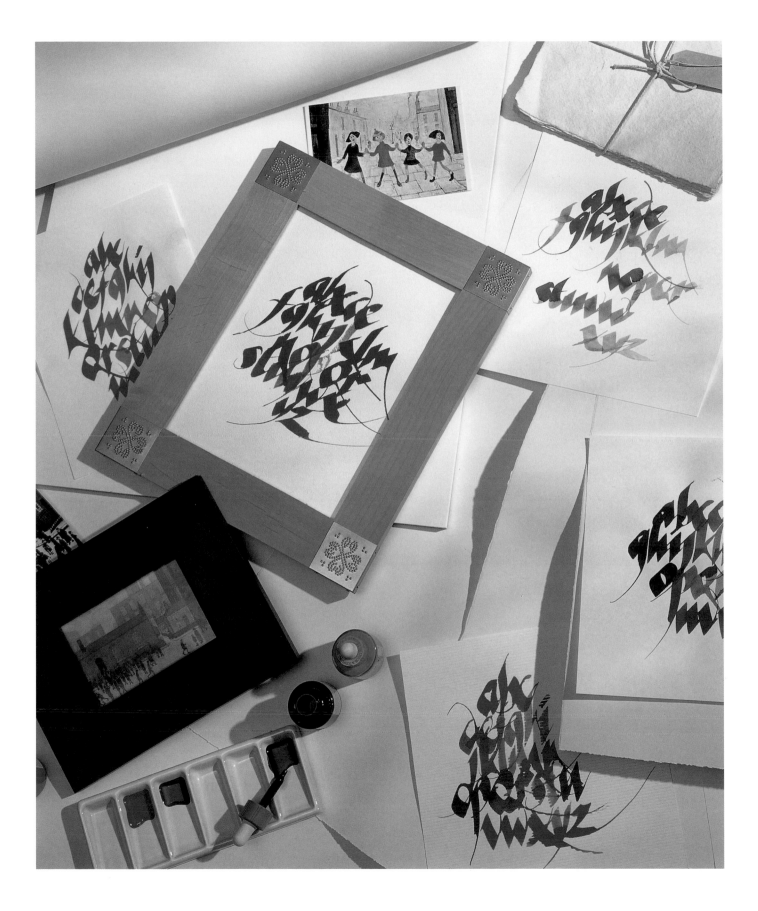

Materials

You do not have to outlay a lot of money on materials and equipment when taking up calligraphy. All you need to make a start are the basic requirements of a pen, ink and paper. You will, however, discover that there are many types of pens, brushes, inks, paints, papers and boards produced with the calligrapher in mind. Naturally you will adapt to using new writing implements and mediums, and in doing so discover which materials you prefer. I enjoy trying new mediums and practising with them on different surfaces in order to discover what effects can be achieved with each. Only by experimenting like this do you discover how different inks and paints behave and which work best on each surface.

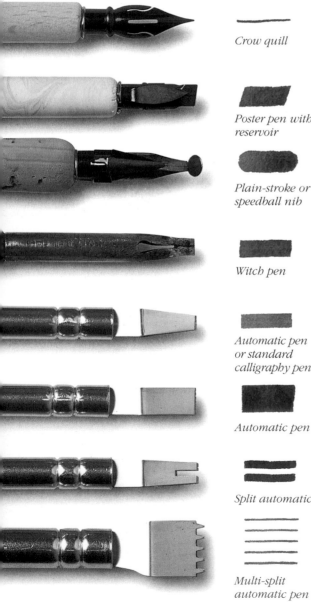

Crow quill

Poster pen with reservoir

Plain-stroke or speedball nib

Witch pen

Automatic pen or standard calligraphy pen

Automatic pen

Split automatic pen

Multi-split automatic pen

Writing implements

Metal nibs and pens
Usually used with ink, but can be used with watercolour or gouache.

Fibre-tip pens
Ideal for practising lettering and layout of designs because you do not have to keep refilling or loading with ink.

Brushes
Available in a variety of shapes and sizes. Flat brushes can be used for drawing letters, and round brushes for loading nibs and metal pens.

Oblique-shaped felt-tip pens of various widths

Wedge-shaped felt-tip pen

Using two pencils

Two pencils taped together is an ideal way to highlight, and increase understanding of the construction of letterforms.

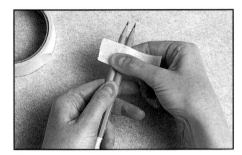

1 Tape two HB pencils together at both ends.

2 Draw letters with the two taped pencils, keeping both pencil points on the surface of the paper and retaining a constant writing angle. The two lines indicate the marks made by each edge of a pen. They are concealed when drawing letters in ink, as shown below.

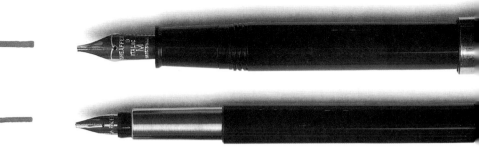

Fountain pens with interchangeable nib sections

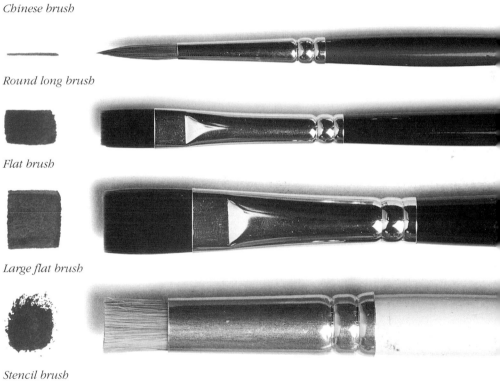

Chinese brush

Round long brush

Flat brush

Large flat brush

Stencil brush

Carpenter's pencil

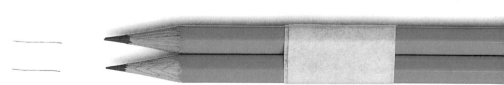

Two pencils taped together

9

Inks and paints

Waterproof and non-waterproof inks

These inks flow freely, dry quickly and do not harm paper or pen.

Watercolour paints

Available in tubes or pans, watercolours are the ideal medium for writing in colour.

Gouache

Used in the same way as watercolour but is opaque.

Enamel paints

Not a calligraphy medium, but used on metal surfaces to fill in areas of letters.

Acrylics

Ideal for practising lettering and layout of designs because you can cover large areas with a brush.

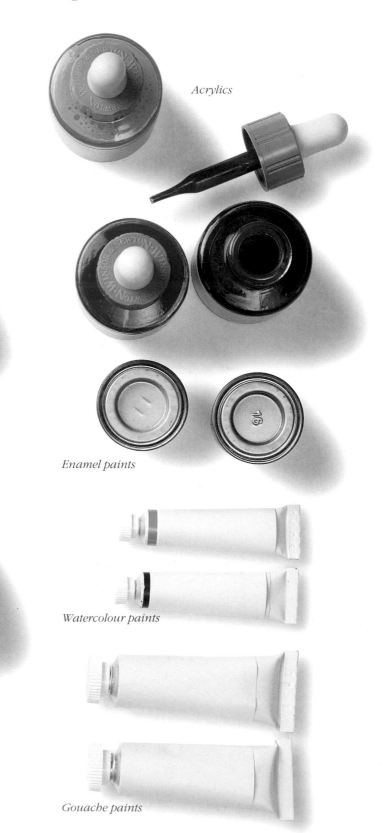

Acrylics

Enamel paints

Watercolour paints

Gouache paints

Inks

Palette to hold paints and inks

Loading ink into reservoirs

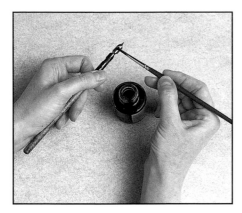

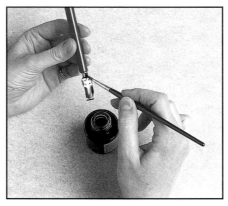

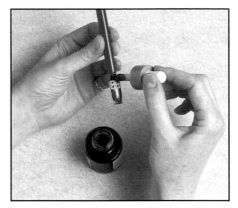

In order to control the amount of ink in the pen reservoir, apply the ink with a small paintbrush.

Pens with a reservoir under the nib should be filled in the same way with a paintbrush.

An eyedropper can be used instead of a paintbrush. In all cases, avoid getting ink onto the wrong side of the nib.

Spray paints

Ideal for using with stencils, on almost any surface.

Ceramic paints

Not a traditional calligraphy medium. To be applied with a brush onto pottery, tiles, glass and similar surfaces when filling in letter shapes.

Masking fluid

Apply with brush or pen. When dry, lay colour over it. After the colour has dried, rub off the masking fluid with your fingertip to expose the paper colour beneath.

Spray paints

Ceramic paints

Masking fluid

Papers and surfaces

Papers

Available in various colours, textures and finishes. Try experimenting on odd bits and pieces before buying larger amounts. Some papers will absorb and others resist ink.

1. *Laid textured paper*

2. *Textured paper*

3. *Lined paper*

4. *Textured paper*

5. *Speckled paper*

6. *Marbled paper*

7. *Cartridge (drawing) paper*

8. *Watercolour paper*

9. *Coloured paper*

10. *Dark-coloured card*

11. *Coloured, lightly textured paper*

12. *Cover paper (thick drawing paper)*

Stretching paper

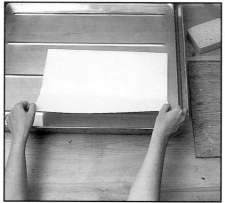

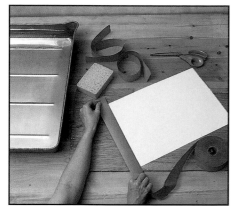

1 To prevent paper from warping when water-colour or inks are applied, it needs to be stretched. You will need cartridge (drawing) paper, gumstrip (kraft tape), a sponge, a wooden board larger than the paper and clean water in a tray or sink.

2 Cut four pieces of the gumstrip (kraft tape) to match the dimensions of your paper. Submerge the paper evenly under the water and leave for one to two minutes.

3 Place the wet paper on the board and smooth it out. Dampen the gumstrip (kraft tape) with the wet sponge so that it is sticky but not too wet.

4 Place a piece of gumstrip (tape) along each edge of the paper. Remove any excess water with a cloth. For security, you can place a drawing (straight) pin in each corner of the paper. Leave the paper flat to dry for six hours or overnight.

Other equipment

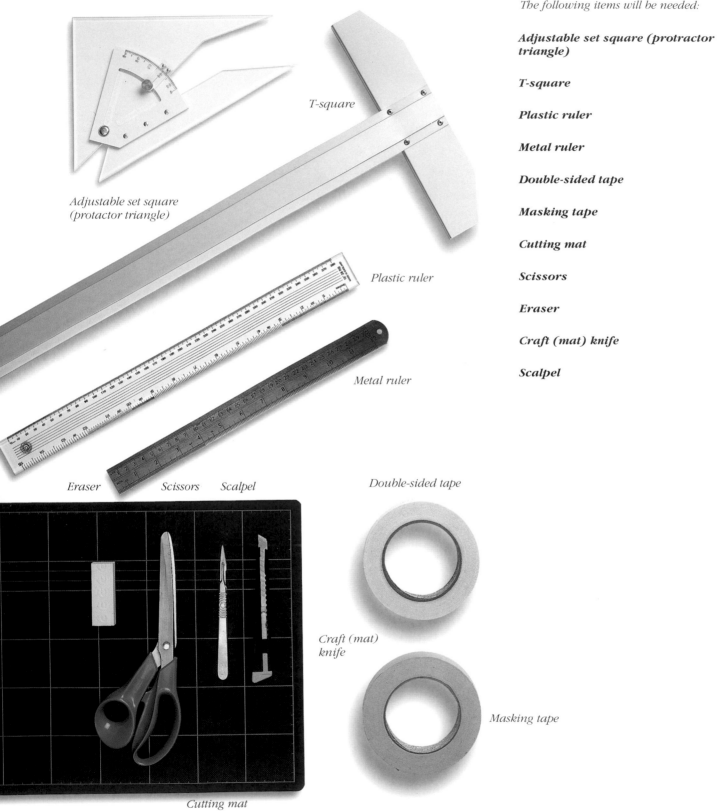

The following items will be needed:

Adjustable set square (protractor triangle)

T-square

Plastic ruler

Metal ruler

Double-sided tape

Masking tape

Cutting mat

Scissors

Eraser

Craft (mat) knife

Scalpel

T-square

Adjustable set square
(protractor triangle)

Plastic ruler

Metal ruler

Eraser Scissors Scalpel

Double-sided tape

Craft (mat)
knife

Masking tape

Cutting mat

Improvised drawing board

It is important not to work on a flat tabletop or surface, because your pen will be upright and so almost at a right angle to your work. On a sloping surface the shallower angle of the pen makes letterforms much easier to draw and also helps the ink to flow more smoothly. The ideal surface is a drawing board, which need not be expensive.

Although adjustable drawing boards can be purchased, you can quite easily improvise. Use a piece of hardboard (Masonite) or laminated shelving board, both of which are available at most timber merchants (lumberyards), and place it on a tabletop, supported by a box or pile of books, so that the board slopes towards you at an angle of between 30° and 45°.

The same surface can be created by resting the board in your lap and leaning it against the edge of the table.

Alternatively, if you are handy at simple woodwork, it is not difficult to construct a tabletop drawing board.

Whichever method you decide to try, you need to be comfortable and unrestricted. Do not sit cross-legged or lean too far forward.

Basic Techniques

In each section of the book, there are instructions, guidelines and hints for drawing the various letter styles. The pen angle given on the alphabet pages refers to the angle at which you hold the pen in relation to the line along which you are writing.

However, there are some points that apply to whichever alphabet you choose, and these are mentioned here. In addition, practical notes are given here on other techniques that are mentioned in the projects, such as découpage and washing-off.

A small amount of practice and close observation of the structure and shape of the lettering and spacing is the key to understanding how to draw decorative letters.

Calligraphers vary in the ways that they sit and hold the pen, but these are some basic tips. When you find an unrestricted and comfortable writing position, keep to it.

Notes for left-handers

If you are left-handed you will already have overcome most of the difficulties of living in a right-handed world, and calligraphy can be mastered too. Owing to the position of the fingers and hand, left-handers initially find it difficult to keep the angle of the nib to the writing line consistent. Once you have overcome this however, your ability will develop quickly. Part of the problem is that your hand will obstruct the work, although you may find that by moving your fingers further up the pen, away from the nib, you can give yourself a better view of what you've already done. Another useful point to keep in mind when practising is to move your whole arm, not just your wrist and fingers.

To start off, try using an oblique-nibbed pen (made especially for left-handers). These nibs are available in a wide variety of sizes. You should concentrate on constructing the shape of the letterforms and producing a consistent rhythm throughout the letters. Never mind if, initially, your serifs or finishing strokes appear strange, they can be worked on later. You might find it useful to position the paper further to the left than usual so that your elbow does not become obstructed by your ribs. It may also be worth placing your paper at different angles. When you discover the best angle, draw a quick template or note it down so that you are able to recreate the angle later.

Left-handers often find Uncial letterforms easier than the others, perhaps because the pen is held horizontally during execution.

Notes for getting started

Set up your board and decide on your letterstyle. Italics or Uncials are both good to begin with. Until you have a bit of experience, it is probably best to use relatively small nibs and widths of pen. You will have more control over the pen, and will also find that your mistakes are easier to spot and correct.

In the beginning, concentrate on keeping the pen nib at a consistent angle to the paper. The angle of the pen varies depending upon the letter style, and the correct angle is given for each alphabet. The height of each letterform is dictated by the width of the nib and relative proportions are given for each alphabet, along with numbered arrows to show the order of the strokes.

On a practical note, you should consider both your seating position, so as not to strain your back, and the lighting conditions. Daylight is best, but angle-poise (extension or arm-swing) lamps are good if you need to work in artificial light.

Finally, do not forget to clean pens and brushes thoroughly immediately after use. This will prolong their life and avoid the frustration of the pen or brush not responding as it should.

Direction of light

The lighting for a right-hander should come from the left, and from the right for left-handers. You should not work in your own shadow; also be careful that the light is not so strong that it causes a glare.

Position of pen

The position of the pen may not be as you write normally. Start off by holding the pen between thumb and forefinger, resting it on the third finger. Use the fourth and fifth fingers to rest on the paper. Make sure you keep your wrist straight and move your arm.

Transferring a design

When transferring a design from layout paper, either use carbon paper and then trace the outline of the letters or, if transferring onto surfaces other than paper, use a compass to make small indents through the layout paper onto the surface.

Protecting work

You may want to use a spare piece of paper to protect your work from fingermarks, smudges or drops of ink. Use masking tape to fix it over your work and to your board.

Layout & design

Analyzing letterforms

When studying or analyzing new letterforms or alphabets, it is useful to learn about the construction and form of the letters by concentrating on the counters or shapes in and around the letterforms. Observing these proportions helps when drawing the letters.

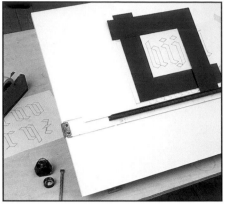

Cut out two relatively large L-shaped frames from black card. Use these when composing a piece of lettering to help your eye concentrate on the shapes of the individual letters and their proportions within the overall field.

Ruling lines

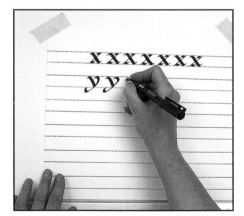

Use the T-square on your drawing board to make guidelines of the appropriate height, to use for practice in repeating letters. The spacing between the lines depends on the alphabet type and the size of your pen.

Using a guideline sheet

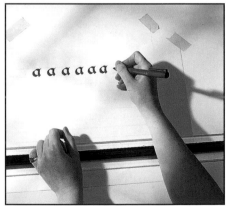

When you are using a letter style for the first time, make a guideline sheet and place it under layout paper so that the guidelines show through. This saves you having to rule guidelines every time you want to practise.

Word spacing

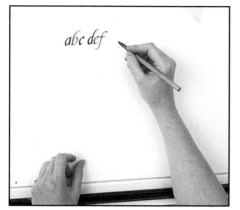

Even spacing between words will come with practice. You will soon notice when spaces are uneven or too large. A good rule of thumb is to leave sufficient space to fit an o between the written words.

Line spacing

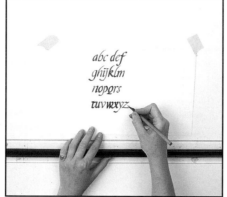

Use multiples of the lower-case x height between each line. Two x heights between each line of lettering is usual, but you can vary this. If the lines are further apart the lettering will tend to be easier to read.

Letter spacing

The aim of letter spacing is to make the spacing of letters seem equal. Different letter combinations require more or less space, depending if they are straight-sided or curved. The counters (enclosed spaces) of letters also need to be considered. Analyze the spaces between three letters at a time.

Balancing large & small

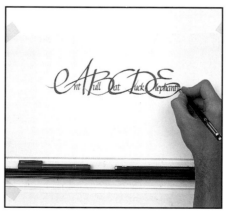

When you have mastered the spacing of letters, words and lines, try using letters of different sizes and styles together. Reassess each letter combination and use the counters and spaces in between letters to create a pleasing overall design.

Additional techniques

Washing-off is an effective technique for creating layers of lettering, some more faded or washed-off than others, in a semi-controlled way. This technique relies on the fact that only slight marks are left behind by water-based paints and watersoluble inks after they are washed off, while waterproof inks retain their intensity.

Washing-off

1 Stretch some paper, as shown on page 13, or choose a sturdy line-and-wash board. Paint either a solid-coloured or patterned background with gouache and allow to dry.

2 Wash off the gouache paint, either in the bath or sink, using a shower or spray nozzle. You may need to lift the paint off the surface of the paper very gently with a brush. The more gouache you wash off, the lighter the mark remaining on the paper.

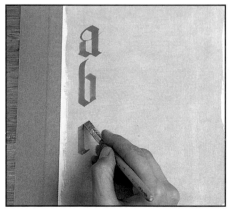

3 Next add lettering in gouache and wash this off also to leave a faint image or stain. Keep adding more lettering in either gouache, watercolour or waterproof ink, and wash it off again. You can do this many times to create different depths and layers.

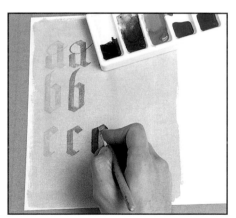

4 Any lettering drawn in waterproof ink will remain stronger than that in gouache and watercolour. Continue to build up the lettering and images until you are satisfied with the design.

Flourishes and hairlines

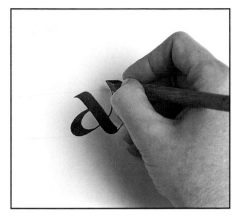

Flourishes and hairlines are endings and extensions of letters, and are used to decorate and embellish lettering. Often added to balance designs or fill awkward spaces, flourishes should blend with the lettering and appear to flow naturally. Practise simple flourishes, and always plan them out on layout paper before applying them to your final design.

Use the corner of a metal, felt-tip or fountain pen to create a hairline finish on letters. Practise twisting and lifting the nib onto one corner all in one swift movement as the stroke is finished. Choose letters that lend themselves to this technique.

Horizontal strokes often require a shorter and slightly different hairline. On reaching the end of the horizontal stroke, bring the pen back to the left and twist downwards at the same time.

1 Extended strokes and flourishes are ideal for joining letters and balancing a design. Build up ascenders and descenders in separate stages. For example, on this h, make a stroke that starts from the top of the ascender and bring the pen around and down.

2 To make this ascender look as if it has curled back on itself, add a stroke from the left to join the end of the previous stroke. Experiment with extending strokes, particularly ascenders and descenders, and linking different letters together.

Combined techniques

Stencilling provides a superbly flexible and quick way of achieving stunning results. Stencils can easily be made from pieces of cardboard or pieces of plastic sheeting. Most paints can be used for stencilling, so choose a type that is suitable for the surface onto which you are working.

These techniques are not usually associated with calligraphy or decorative lettering, but when used with appropriate letterforms, interesting and unusual effects can be created.

Stencilling

1 Before making a stencil draw your letters onto a piece of paper, leaving plenty of space between each. Then transfer the letters onto thick card (to be the stencil). To make a durable and hard-wearing stencil use acetate instead of card.

2 Cut out the letters carefully, using a sharp scalpel. You will discover that care has to be taken cutting the counters of certain letters. Practise cutting out letters on layout paper beforehand.

3 Tape the stencil in place. Draw centre-points or vertical and horizontal lines on the stencil to aid in lining it up before applying the paint.

4 Stencil brushes are available in many sizes and can be used to apply watercolours, inks, acrylics and ceramic paints. Other methods of applying colour include sponges and spray paints. Experiment by mixing colours within each letter.

Découpage

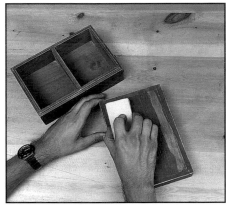

1 This technique involves cutting out paper images and gluing them onto objects. The surface of an object needs to be correctly prepared by sanding and applying primer or undercoat.

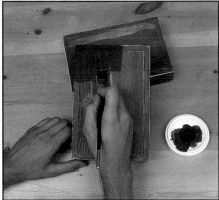

2 Apply a thin coat of paint to the object. Household emulsion or artists acrylic paints can be used. You may want to execute a paint technique, such as sponging, stippling or marbling before adding the cut-out letters.

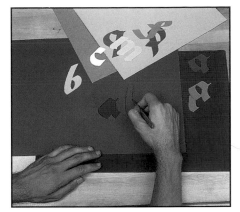

3 Cut out the letters or shapes from the paper. It is best not to use paper that is very thick, especially if the object to which you are gluing the shapes is curved.

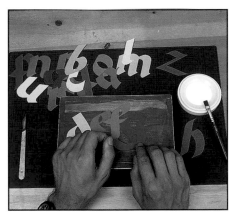

4 Fix the cut-out letters to the object with either PVA (transparent-drying glue) or spray fixative. If using spray fixative spray the cut-out shapes in an old cardboard box to contain the spray mist.

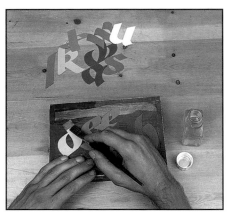

5 Finish off the découpage with several layers of varnish to seal in the cut-out letters. Two or three coats should be sufficient, but ideally you should varnish until you can no longer feel the edges of the letters.

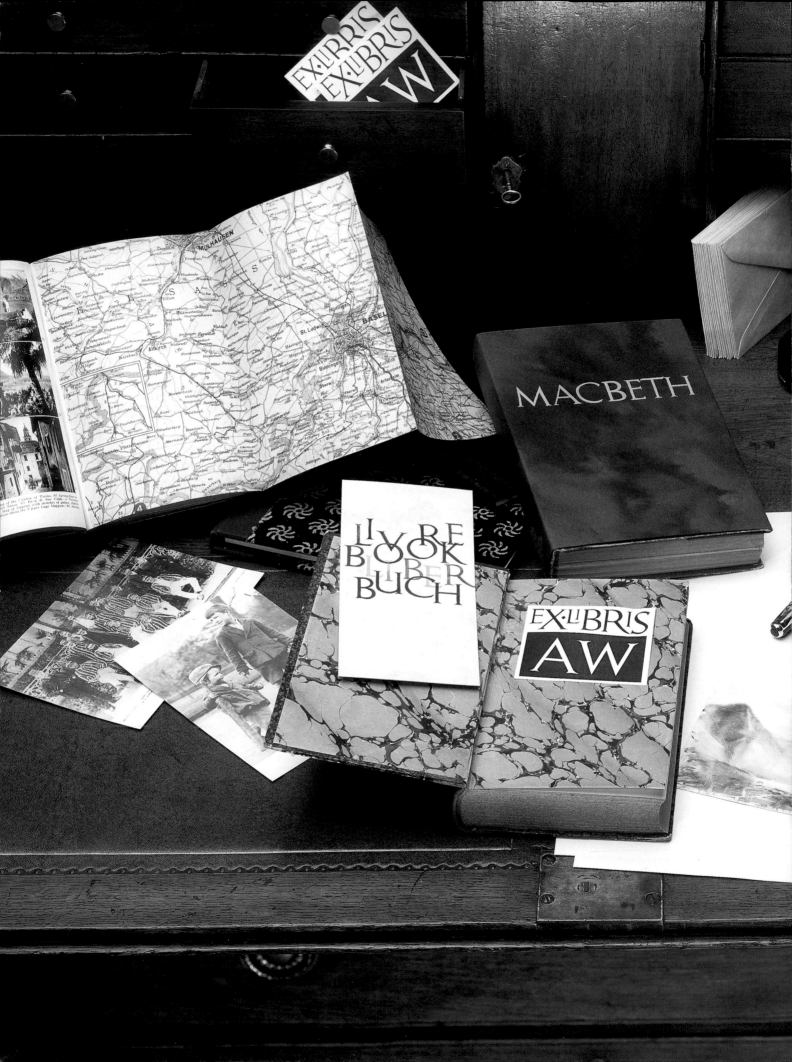

Roman

The origins of the modern Western
alphabet date from the 1st century AD,
and the 23 letters that were used throughout
the Roman Empire.

These most elegantly formed letters are
based on the square and the circle, and
although they can be constructed with a
brush, their true strength is shown when they
are carved – enabling the fall of light and
shadow to enhance their characteristics.

Memorial stone
The beautifully carved Roman capitals on this memorial stone at Ostia in Italy show clearly how the fall of light and shade give the letters strength and character.

The origins of the Roman alphabet

Western society owes much to its Greek and Roman ancestors, including the origin of the alphabet that we use today. In the 5th century BC, written accounts of myths and histories appeared in Greece in an alphabet that had been derived from the abstract symbols of the cuneiform language of the Babylonians and, before that, the hieroglyphics, or picture symbols, of Ancient Egypt. As the Greeks travelled extensively throughout the Mediterranean area, trading and founding colonies, their script spread to several countries, including parts of Italy.

When the Roman Empire displaced Greece as the leading civilization in Europe, it adopted the Greek alphabet and used it

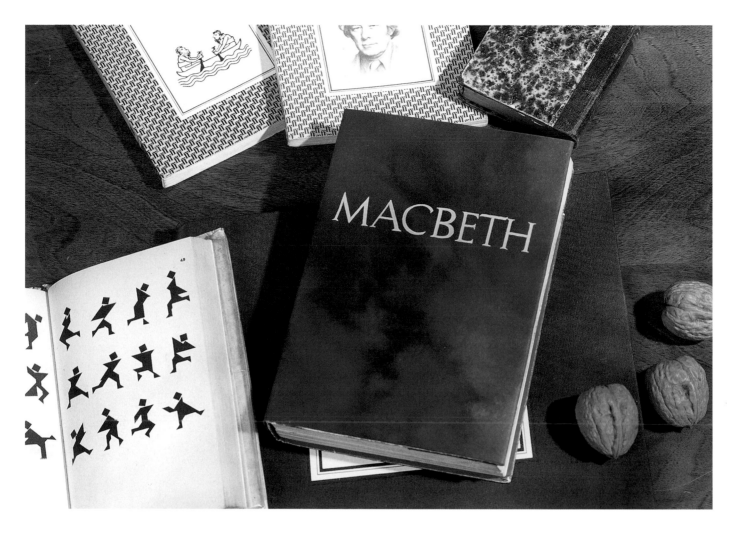

as the basis for its own square capital letters, which were originally designed for carving. The Roman alphabet consisted of 23 of the 26 letters in the modern European alphabet, J, U and W being added in the Middle Ages to accommodate some of the northern European languages.

The Roman Empire was a well-organized and literate civilization that expanded rapidly in Europe and the Middle East. The maintenance of trade and government over such a wide area required a lot of administration and therefore provided much work for professional scribes and stone carvers. Many Roman monumental inscriptions carved in stone or marble can still be seen today all over Europe, on arches, buildings, statues and tombs, using the elegant Quadrata or Roman square capitals, and they relay to us much of Roman history.

Construction of the letters

The Romans considered lettering an important art, and carvers and scribes devoted considerable time to perfecting letterforms. The classical Roman capitals are based on the square, letters occupying a specified vertical division of the square - half width,

Book cover

The background for this book cover was worked on red paper that had first been stretched (see page 13). The paper was re-wetted and black ink was applied gently and allowed to run. More water was added and the whole board was agitated to create an atmospheric, cloud-like background. The paper was left to dry and then cut from the board. The dimensions for the book cover were lightly marked in pencil, and the title of the book drawn in gouache with a brush.

Remember to select a sheet of paper that allows room for the spine, back cover and front and back flaps as well as the front cover. When the cover is finished and all the lettering is dry, cut out the cover, lightly score and fold it along the fold lines and wrap it around the book.

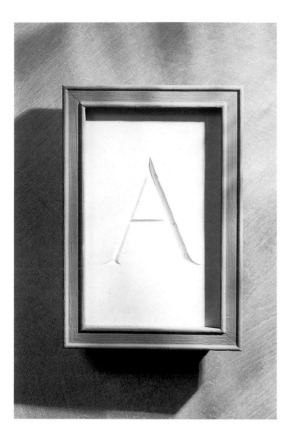

Carved A

Creative calligraphy includes experimenting with materials other than pen and ink and on surfaces other than paper or card. Carved or relief lettering, for example, can be very effective, and Roman capitals are the perfect letterform to carve. In addition, as you will need to observe the letters closely in order to carve them, you will learn much about their construction and shape.

The letter A illustrates the strength and impact that can be created from the fall of light and shadow on carved Roman letterforms. To accentuate this effect, you could paint the carved letter, perhaps in two colours, one for each side of the strokes. The piece can be mounted in a painted wooden frame to hide the uneven edge of the plaster-of-paris block.

three-quarter width and so on. Round letters are based on the circle, which fits into a square. They discovered that in order to make lines of letters look even in size and spacing they had to use optical illusion and visual spacing. The round letters were therefore enlarged fractionally compared to the others, and the spaces between different letters were varied. The basic geometric structure of the letters, the relationships between thicks and thins, curves and straight lines, and the construction of the serifs were all carefully considered and convey both strength and beauty. In terms of design and proportion these Roman square capitals have been acknowledged as the closest to perfection of all letterforms.

These square capitals were also drawn with brush and pen, but they could not be so easily constructed with these materials because the forms were originally designed by stone carvers to suit the shape and action of the chisel. As the use of written documents increased, so did the demand for an alternative lettering style that was better suited to writing materials, and this led to the emergence of Rustic capitals, an ideal alphabet for handwritten manuscripts. Compressed and less formal, these letters were easier and quicker to produce and took up less space, making them more economical in time and materials. Headings and initial letters remained in square capital form, just as they do today.

The basis of western alphabets

Having survived and developed over the last 2,000 years, the Roman alphabet has provided letters that form the basis for a wide range of handwritten and calligraphic styles, and many varieties of lettering styles have been based on the skeletal structure of these distinctive letterforms. In this book the various letter styles are placed in the order in which they were created or developed through the ages. If you are a newcomer to calligraphy you may find it easier to try some of the other letterforms, such as Uncials or italics, before attempting classical Roman square capitals. Owing to their origins as carved letterforms, square capitals are not easily constructed with edged pens. The serifs and finishing strokes in particular require patient practice and a delicate touch, although you may not find them difficult to master once you have become accustomed to calligraphy tools and materials. Having said this, it is worth studying, or at least referring to these historically important letterforms before embarking on other forms, as so many of them have been based on, or at least echo, characteristics found in Roman forms.

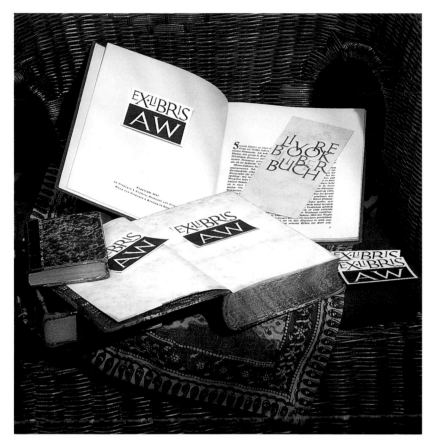

Ex-libris plate and bookmark

If you are a keen book collector, ex-libris plates provide a good opportunity to practise calligraphy. First create your image using a black felt-tip pen on white paper. When you are happy with your design, reduce it on a photocopier until eight copies will fit onto one sheet of paper. Make eight copies and paste them onto a sheet of white paper and make small cropping marks at all four corners of each plate. Photocopy this sheet as many times as you need to for the number of plates you want. Cut out the plates using the crop marks and paste onto the inside front covers of your books.

The design for the bookmark was planned on layout paper. To do this, first draw all the letters on layout paper and cut round them, then move them about and overlap them until the composition is satisfactory. Tape the pieces down and trace the whole design onto another piece of layout paper. Transfer this onto the bookmark card and then, using gouache and a paintbrush, fill in the letters. The letters can each be a single colour or, as here, they can be multi-coloured (see page 68).

Plaster of paris

Plaster of paris (available from art and craft stores) is very manageable, and is easy to carve into with a scalpel or sharp craft (mat) knife. You do not need expensive equipment or materials to produce interesting designs. To make a block for carving, line a tin or box with a piece of plastic taken from a plastic bag. Mix the plaster of paris with water according to the instructions and pour it into the tin or box. When it is dry, turn out the lump of plaster; the plastic should peel off easily, revealing a smooth surface. Carefully draw your letter with a thin felt-tip pen, then carve it with a scalpel or knife, keeping the knife at the same angle to the plaster. You may find it useful to draw a guideline down the centre of each stroke before you start removing the plaster of paris.

Roman capitals

Cap height: *9 nib widths*
Pen angle: *30° or 45°*

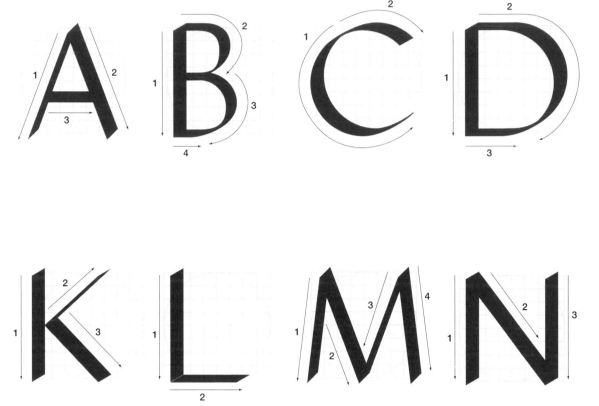

The proportions of Roman capitals are based on a circle and square.

Most letters are drawn with the pen held at 30° to the line of writing. Use a pen angle of 45° for the A, M, N, V, W, X, and Y. Draw the diagonal stroke of the Z with the pen held horizontally.

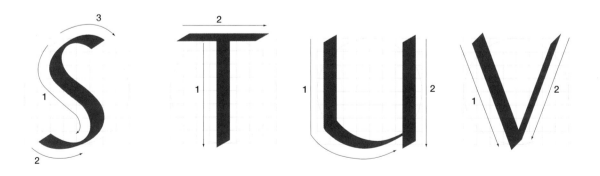

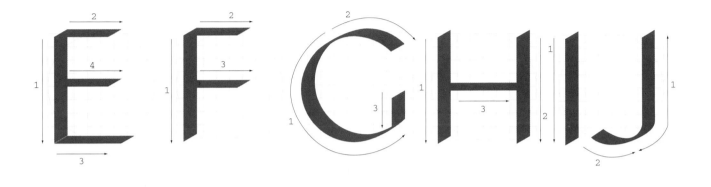

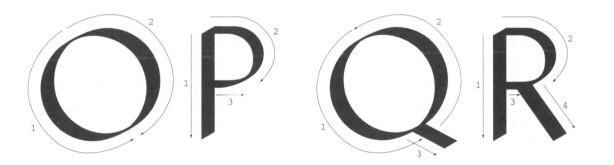

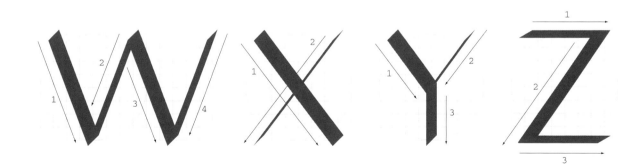

Condensed
Roman capitals

Cap height: *9 nib widths*
Pen angle: *30˚*

These letterforms are constructed in the same way as those on pages 30 and 31. The serifs are created with two strokes. When drawing the second part of a serif you will have to use the corner of the metal pen or nib.

A B C D

J K L M N

S T U V

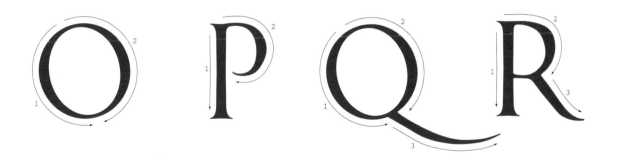

Uncials

Weighty, rounded forms with emphatic contrasts in the thick and thin strokes, Uncials are acknowledged as the inspiration that produced the famous Book of Kells and the beautifully decorated Lindisfarne Gospels. Upright and bold, these letters have a simple construction. They produce a pleasing texture and combine well with other scripts.

The Book of Kells

This page from The Book of Kells shows the Genealogy of Christ, from St. Luke's Gospel 'xp' to St. Matthew. Produced in the 8th century, the pages are extremely detailed; many are decorated with images painted in and around the letterforms.

The development of Uncials

Uncial letters appeared during the 4th century AD as a development of both Roman square capitals and Rustica letterforms. For a time the Romans were using all three letterforms, with the Uncials providing the transition from majuscule (capitals) to minuscule (lower-case) forms. This new script became the main book hand for late Roman and early Christian writings and it continued to be in regular use until the 8th century.

During this time formal documents were written on parchment and vellum, with the reed pen increasingly making way for the quill, and these materials allowed for greater speed and flexibility. Uncials were originally contained between two

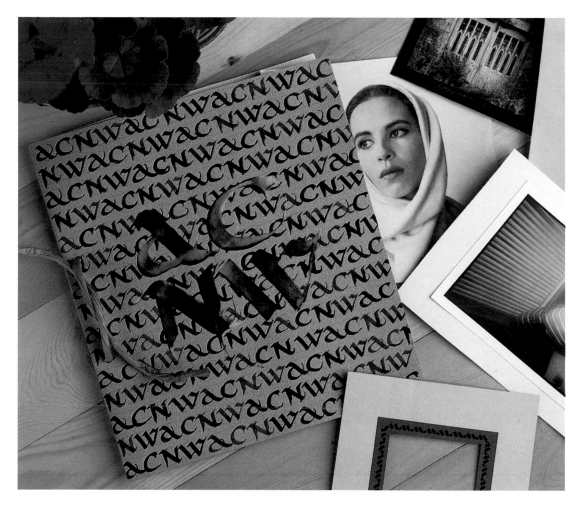

horizontal guidelines, giving a fixed letter height, with only small ascenders and descenders. The Uncial was then followed by the Half-Uncial, in which, for the first time, some of the letters cross the writing line (the band formed by the two guidelines), forming ascenders and descenders more as we tend to recognize them today, and this development gradually led to the increased use of minuscule lettering. It took time for Uncials to become popular, and for scribes to realize that these highly decorative, round characters provided a refreshing change to previous letterforms.

Uncials became the standard script of the early Christian Church. Throughout northern and western Europe, evangelists and missionaries began writing the Gospels in highly decorated books using Uncial and Half-Uncial letterforms. Excellent examples include the Lindisfarne Gospels and the Irish Book of Kells. Although Uncials are closely identified with manuscripts of the early Christian Church, they have a contemporary feel both as individual letters and when used for blocks of text. It is probably this aesthetic quality that has influenced and convinced scribes and calligraphers throughout the centuries to continue to use the Uncial letterstyle.

Photo album

The background on this hand-made photograph album exploits the regular texture created by a repeat pattern of Uncial letters. The letters are drawn in blue ink with an automatic pen on fairly thick card. By drawing larger Uncials in a square format with pen and ink, and then drawing over them with diluted bleach, it is possible to make some rows of lettering appear to recede. The four large-scale initials, drawn with more freedom and with slightly flourished serifs, come forward from the other letterforms and catch the eye first.

This photograph album is simple to make. Fold a large piece of card in half, and make two holes through both thicknesses on the folded edge with a hole-puncher. Insert as many sheets of paper as you need, also with holes punched in them; thread raffia or string through the holes and tie at the front.

The characteristics of Uncial alphabets

Constructed with the end of the pen nib held parallel to the line of writing or at a very slight angle, these open, rounded letters have a friendly appearance, which is perhaps partly responsible for their popularity. In addition, the position of the pen or brush creates a distinct contrast between the thick and thin strokes of each letter. As the characters have fairly thick verticals, Uncial letterforms appear quite squat, and you can use this quality in your designs. Rows of words, or groups of letters such as someone's initials, written in Uncial letters, can produce a regular texture that is ideal for creating a repeating pattern.

Careful choice of papers, inks and colours enables you to create very different images and results. Try using rows of repeated Uncials, perhaps an alphabet or the name of a friend or relative on wrapping paper for a present. Plain wrapping papers are available in a range of different surfaces, and when inks and paints are applied by brush or calligraphy pen to some of these, unusual and interesting effects can result.

Once you have mastered the Uncial characters, experiment with creating serifs in different ways. Instead of drawing the more precise serifs shown on pages 40-43, use the corner of a metal pen to produce hairline (very fine) finishes to certain strokes (see page 21). This can be done by quickly twisting the pen nib while moving it in a continuous curve at the end of a stroke, just before lifting the pen from the page. This is much easier to execute than it sounds. Try it out on a layout pad and you will be surprised at how quickly you can achieve control of the corner of the nib. Practice should give you the confidence to try more elaborate flourishes and extensions to letters.

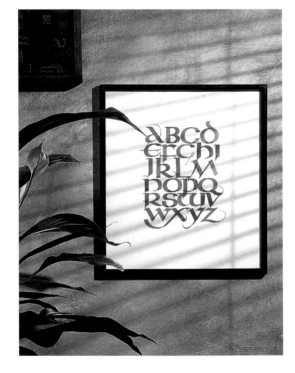

Uncial alphabet

Alphabets are excellent vehicles for designing interesting compositions. This Uncial alphabet, arranged in a rectangular block, was drawn in red ink with an automatic pen. When designing this type of composition, take plenty of time planning it on a layout pad, first working out how the letters should join, overlap or sit alongside each other in order to achieve balance and good spacing.

Sealing and gluing on a wooden surface

Before sticking paper, card or lettering onto wooden items, you must prepare the surface correctly. After sanding, priming and painting the surface with your chosen paint technique, seal it with either a varnish and PVA solution or just PVA solution. Paper with lettering on it can be fixed to this surface with undiluted PVA.

You can seal the paper to the wooden object with several layers of varnish, as with the découpage technique on page 23.

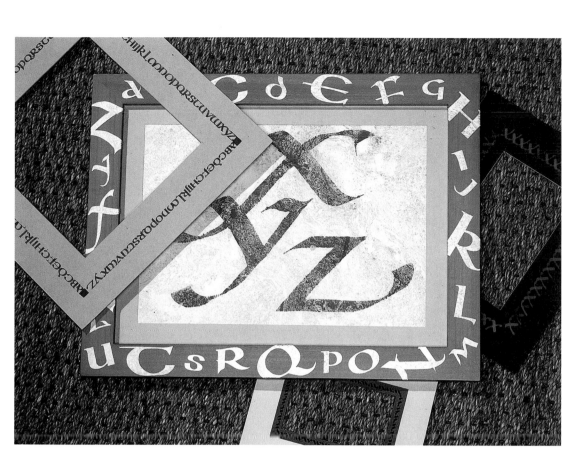

Picture frame and mounts (mats)

The repeat-pattern quality of Uncials can be used to create rich borders around blocks of calligraphy. If the letters are drawn very close together, or if they touch or slightly overlap, their dense textural character creates an intricate abstract border pattern. Picture frames and mounts (mats) are ideal vehicles on which to exploit these effects.

The wooden picture frame uses Uncial letterforms cut out from wrapping paper and glued onto the frame (see opposite). The mounts (mats) have been created by repeating letters drawn in ink and then in a bleach solution (see page 135) with automatic pens on pieces of mount-board (matboard) in a selection of colours.

Storage-jar labels

Because they are very legible, Uncials can provide a refreshing style of lettering for single words, for decorating or labelling objects, even when the lettering is turned on its side and runs vertically.

These labels have a simple, pale background wash applied to stretched paper (see page 13) with a large, flat paintbrush. The lettering was added in a darker shade of the same colour, in gouache.

The labels can be secured to the jars with double-sided tape.

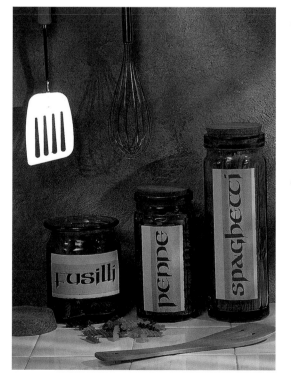

39

Uncials
Upper case

Cap height: *4 nib widths*
Pen angle: *0° (horizontal)*

Uncials are relatively easy and quick to draw. You may like to change the pen angle to 20º to create an Uncial alphabet with a slightly different look.

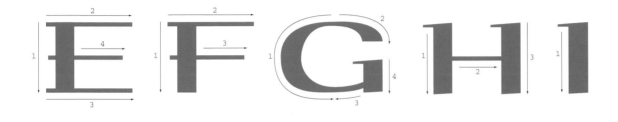

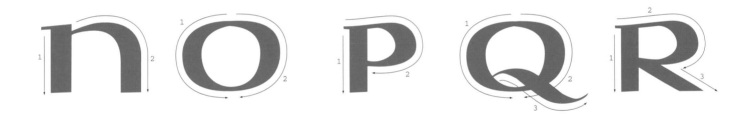

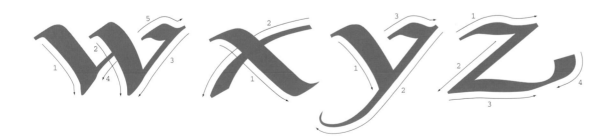

Uncials
Lower case

x height: *4 nib widths*
Pen angle: *0° (end of nib parallel to writing line)*

The position of the pen creates a distinct contrast between the thick and thin strokes of each letter.

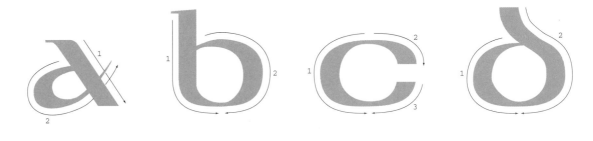

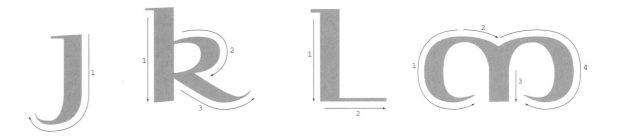

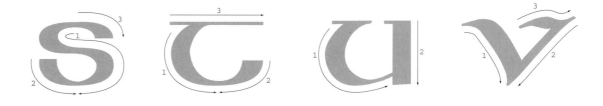

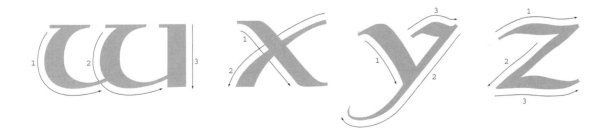

Archimedes - Winston Churchill
Le Corbusier - Jacques Cousteau
Vasco da Gama - Alberto Giacometti
Thor Heyerdahl - Guglielmo Marconi
Pablo Picasso - Marco Polo
Wilfred Thesiger - Leonardo da Vinci

Caroline Manuscript

This style of lettering was originally employed by monks and copyists during the 9th and 10th centuries for manuscripts and religious texts. Quite open and spacious, these letterforms have similar proportions to their Roman predecessors, which makes for good clarity and legibility.

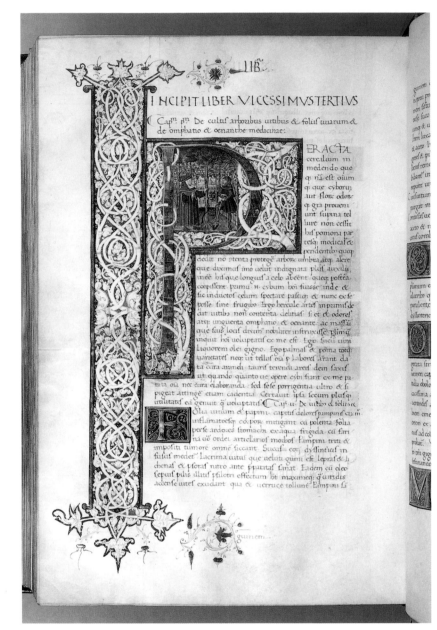

Pliny's Natural History
This decorative page in Caroline Manuscript is from Pliny's Natural History, *and was produced in Italy during the 15th century.*

The first lower-case alphabet

Following the collapse of the Roman Empire many variations on the Roman scripts, particular to different areas, began to appear throughout Europe. At this time itinerant priests provided the main link between religious centres in different regions, and they spread new ideas and developments in letterforms and written text throughout the continent. By the end of the 8th century such a diversity of scripts was being used that Charlemagne, the first king of the Franks and Holy Roman Emperor from 768 to 814, decided that a standardized form of minuscule (lower-case) script should be devised to replace all the variations currently in use throughout his empire, which included substantial areas of western and northern Europe.

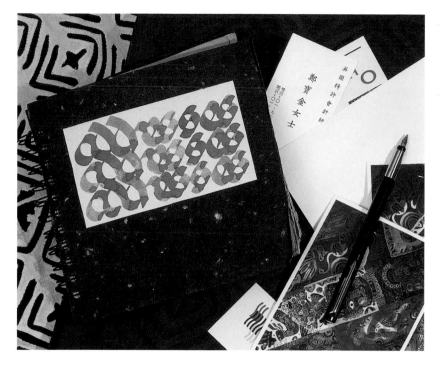

Address book

A notebook can be converted into a personalized address book through the addition of a specially designed cover or front piece. This is a relatively quick project as the front piece can be drawn in ink on paper and pasted onto the front of the book. The words were drawn almost touching each other, sacrificing some legibility but producing a striking overall design.

In addition, Charlemagne was concerned by the ever-increasing number of textual errors that had crept into manuscripts over the centuries. Monks and copyists made mistakes that were then repeated by later copyists, who would also introduce their own errors, until in some cases the meaning of whole passages of text was inadvertently altered. Charlemagne's solution was to commission new copies of the Gospels and other religious texts, to be produced from the earliest or best-authenticated sources, and to be undertaken with the greatest care and attention. Responsibility for developing a standard hand and supervising the task of making the new copies fell to the English monk, Alcuin of York, who in 789 was appointed to supervise the school at the monastery of St Martin at Tours, France.

Alcuin referred back to both the square and Rustic capitals of Roman alphabets, as well as to Uncial and Half-Uncial letterforms in creating the first true minuscule script. Named Carolingian Minuscule (also called Caroline Manuscript), this letterform became the standard book hand adopted by monks and copyists throughout Charlemagne's empire. Such was the impact of Charlemagne's reform that Carolingian Minuscule continued to be used in many parts of Europe, and by the 10th century it had reached England, where it was employed extensively.

Irish scribes of the 9th century were also beginning to use true minuscule hands in producing manuscripts. Examples of these letterforms can be found in copies of the Lindisfarne Gospels dating from this period, in which scribes wrote translations in Carolingian Minuscule between lines of text which were written in Uncial lettering.

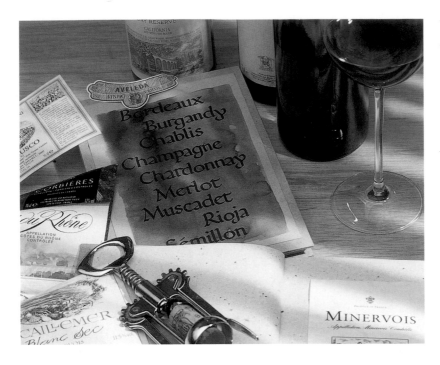

Wine book
A book in which to note down wines that you have tasted, their origin, the grapes and vintage, and the date tasted, or even just to keep the labels in, can provide an interesting and useful source of reference. This cover was made by stretching a sheet of paper (see page 13) and then laying down a background wash of red wine, which will usually change the colour of the paper quickly. The names of favourite wines have been added in ink with a metal pen.

In the process of rewriting various manuscripts in the new script, Alcuin and his successors also began to consider the hierarchy of different parts of a book, such as headings and titles, and their relationship to the text. It is probably fair to say that not since the creation of the Roman alphabet had such an important development occurred in the history of writing as that represented by the birth of Carolingian Minuscule. These letterforms can be classed as the first genuine lower-case alphabet, with longer ascenders and descenders than had previously been seen. Roman square capitals were often used with Carolingian Minuscule as there were no upper-case letterforms. The Carolingian Minuscule and Roman forms share a sense of proportion and a sensitive movement between thick and thin strokes, and sit well alongside each other. Although often written close together, these letters are quite open in themselves and create an interesting rhythm.

Matching alphabet to object
When deciding on a lettering style for a particular project, first choose a theme and then look for an alphabet that seems sympathetic to that theme. All the alphabets in this book, excluding the contemporary ones, are reminiscent of different periods in history. Carolingian Minuscule seems to convey a very strong medieval feel, and works well for projects with a historical theme, such as a family tree.

One quality that all good designs have in common is appropriateness in some form, either through shape, style, colours or materials, to the subject matter. Calligraphy provides a particularly good outlet for playing around with these different

elements because use can be made of different sizes and scales of lettering, and one style can be juxtaposed with another to produce unusual and effective designs. In addition, modern calligraphers can take liberties with historic letterforms as they have the advantage of more styles, methods and materials to choose from than were available to the scribes of centuries past. Whereas the scribes were usually concentrating primarily on legibility and clarity, today letters can be used in endless ways, the only limitation being the boundaries of your imagination. You can use letterforms for their beautiful individual shapes, or for the accumulative abstract patterns created when, for example, you overlap letters of various sizes. You can take sections of letters, cropping closely into them, and highlight the shapes and forms found within the letters or the spaces in between them. Try to make use of these negative shapes in and around letterforms as they will help you to understand the construction of letters and make them easier to draw.

Scrapbook sleeve

The design for this scrapbook sleeve makes use of the names of famous people, drawn in ink with an automatic pen on a sheet of patterned paper. The edges of the paper have been burnt and singed to create an antique look. To make the cover, which can be slipped on and off, fold the paper around the outside of the scrapbook and join the ends with double-sided tape.

Alternatives to ink

In addition to the mediums commonly used for calligraphy, there are many unusual ones that are fun and rewarding to experiment with, often with surprising results. For example, tea or coffee solutions can create the look of old, antiquated lettering, as on a manuscript weathered by time.

Caroline Manuscript
Upper case

Cap height: *5 nib widths*
Pen angle: *30˚*

While retaining some of the Uncial characteristics, these letterforms have a stronger sense of order and proportion, with more vertical strokes.

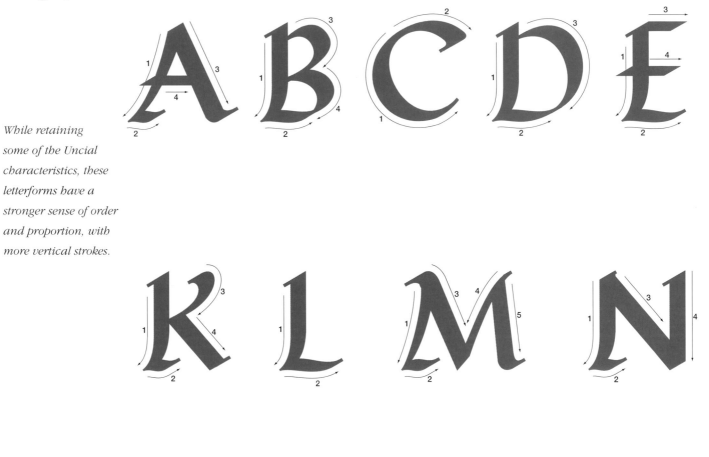

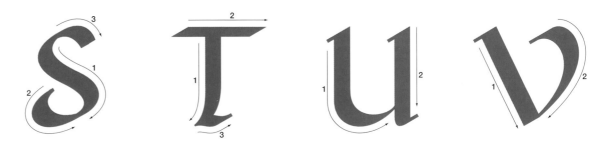

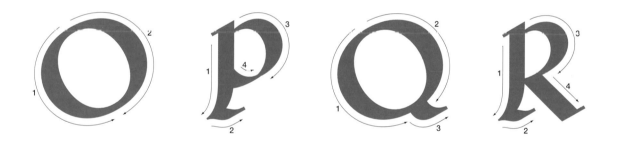

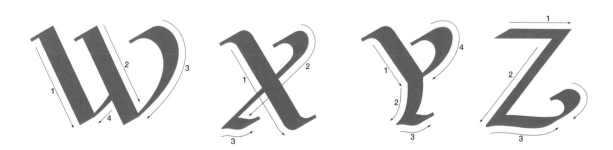

Caroline Manuscript
Lower case

x height: *5 nib widths*
Pen angle: *30˚*

The simple structure and shapes of these letters are quick to draw and provide a steady rhythm when used for a piece of text. This consistency is not broken up by thin hairlines or flourishes.

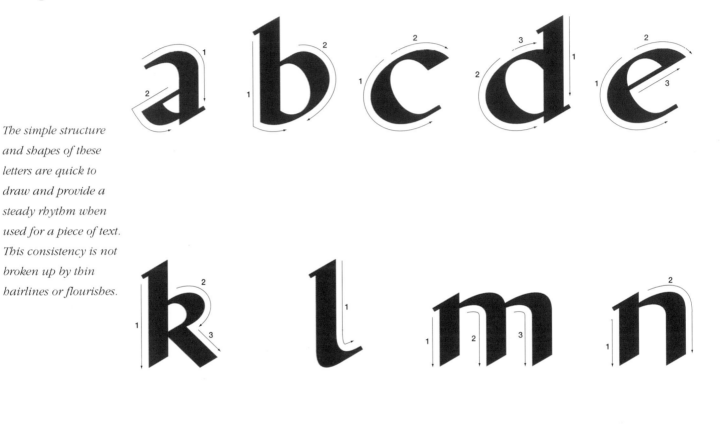

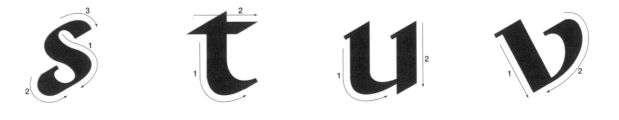

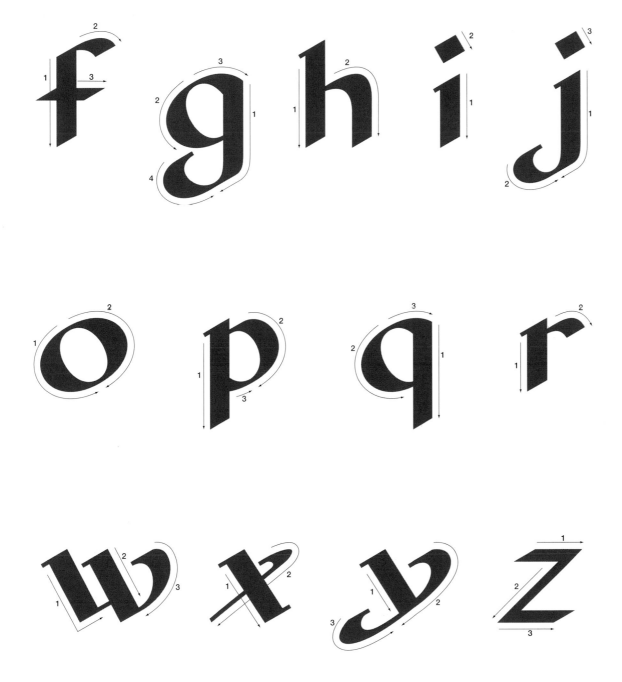

ABCDE
FGHIJK
LMNOP
QRSTU
VWXYZ

Versals

Usually used as initial letters rather than text, Versals can be very elaborate and decorative. Scribes would use them as we use dropped capitals, to indicate new paragraphs or passages of text. When used large-scale, these letterforms are ideal for embellishment with patterns and textures within the strokes.

The Dover Bible

This page from the Dover Bible *shows the opening of St. Matthew's Gospel. Versals have been used to provide emphasis to certain important words on the page.*

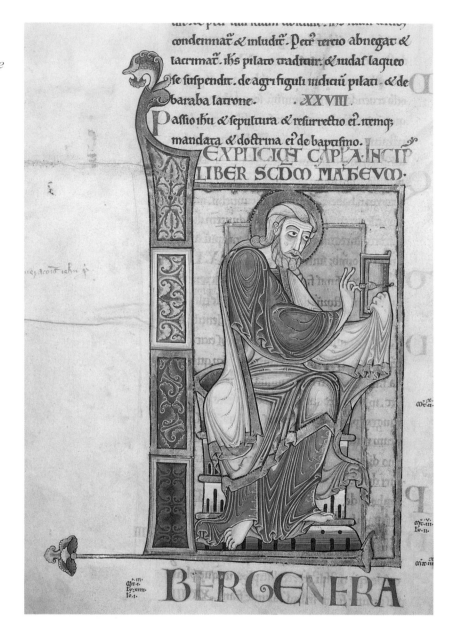

Decorative capitals

Versals are capitals used primarily as initial letters. They are not usually employed as a text script. They were devised to indicate the opening of a chapter, paragraph or passage of text, and to draw the reader's attention to important pieces of information. These letterforms are ideal for decoration as their pleasing, full and open shapes, formed by wide strokes, can have a stunning impact. Not having a lower-case form, Versals were generally used with Uncial, Half-Uncial or Carolingian Minuscule.

The structure of Versals is based on the simple forms of Roman capitals. However, scribes in Italy developed the more elaborate Lombardic forms, with the letters B, F, I, L, Q, R and U showing characteristics of Uncials. Used for manuscripts, these letterforms displayed hairline (very fine line) decorations and

flourishes, and incorporated abstract motifs such as small dots and diamond shapes within or even between the strokes of each letter. As scribes looked to embellish their manuscripts further, they introduced brightly coloured figures, animals and flowers alongside the letterforms.

Tiles

Quite expanded Versals are used on these tiles to fill the square shape, each letter being decorated with a different pattern. Letters can be drawn directly onto tiles or pottery with ceramic paint, which is permanent. Or you first draw the outlines in felt-tip pen, which can be wiped off and redrawn until the lettering is correct in terms of size and positioning. Paint the outside strokes first and then the space inside.

Vase

Many pottery and ceramic shops sell items onto which you can paint your own designs. This rather plain vase has been brightened up with the application of lettering and a motif using ceramic paints.

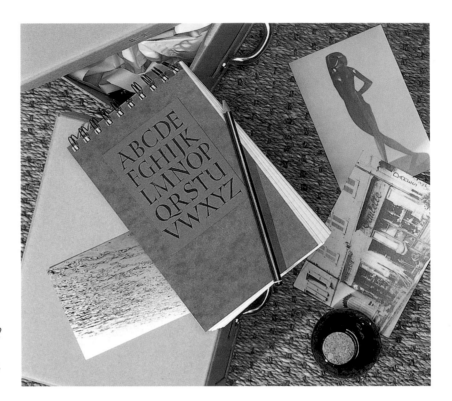

Notebook

A notebook has been given more interest with the addition of a Versal alphabet. The letters have been drawn in black ink on blue paper, which is then pasted onto the cover.

Producing Versals

Versals are constructed in a different way to most other calligraphic styles in that they are built up from a series of strokes. However, as when producing any calligraphy, the hand and whole arm, not just the fingers and wrist, should move, much as they do when you draw at an easel. Versals can be described as drawn, rather than written, forms because a number of strokes are used to complete the main outline of a letter, and then the area within the outline is filled in. However, the character of the letters, and particularly of the serifs and flourishes, is still very much dependent upon the pen or brush stroke. Through practising Versals you will discover that better letterforms tend to result from swift, spontaneous drawing.

Versals are perfect for large-scale work because they have great presence while still allowing for much detail, especially within the strokes of the letters themselves. You may want to try expanding or condensing these letterforms, depending upon the particular project you have in mind. Why not try to exaggerate the outer curves of these letters and, in contrast, add thin hairline flourishes as finishing strokes?

Versals are wonderful, versatile letterforms that can be given plenty of character, and they also have the advantage that they can easily be personalised to give an individual appearance to each letter. You can have a great deal of fun adapting and designing your own Versal letterforms on a wide variety of different projects.

Gift tag

Relatively small and quick to produce, gift tags are ideal for trying out new inks and paints. This example uses Versals drawn in red gouache, with the letters filled in using the same colour. The spaces in and around the letters have been filled in with blue gouache using a brush. Note that the blue does not touch the letters; there is a thin space where the colour of the card shows through.

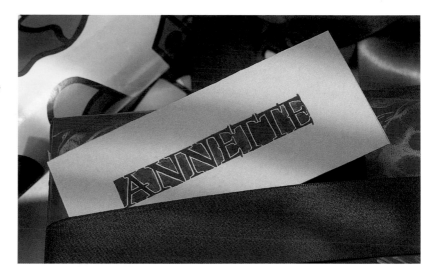

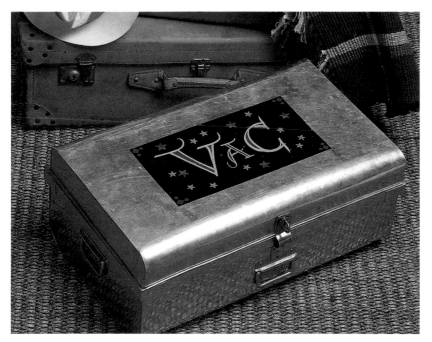

Trunk

Enamel paints were used on this metal trunk because they are quite durable. The dark blue background is applied first, after marking the area with masking tape. A sharp scalpel run around the edge of the masking tape when the background is dry will give a straight edge. The letter outlines were drawn on paper and transferred onto the trunk by pricking through the paper with a compass (see page 17). The letters were then painted following the pin-pricked outlines. Decorative motifs, such as the stars, can be applied in the same way or with a stencil or template.

Versals

Cap height: *18 nib widths*
Pen angle: *30°*

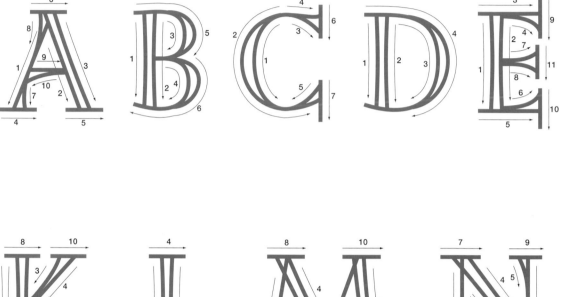

Due to the nature of construction, Versals have very thin 'thins' in relation to the cap height. This is because the letters are created by drawing both sides of the verticals separately, with a narrow-nibbed pen. The centre of each letter can be filled in – see pages 62–63.

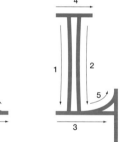
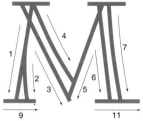
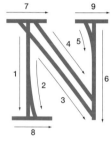

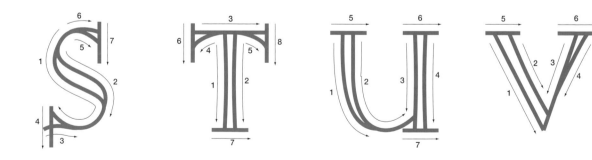

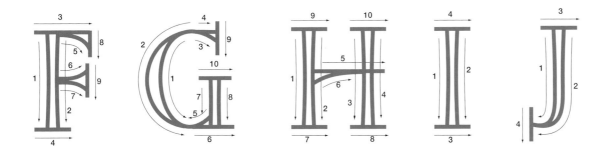

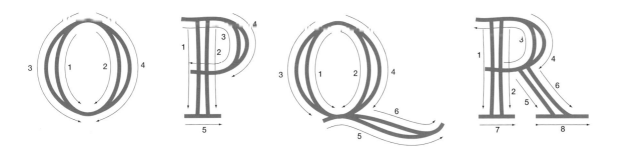

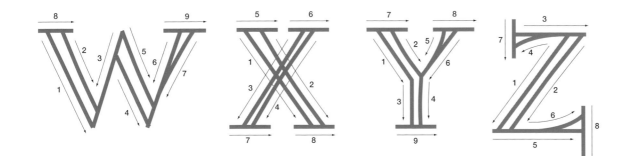

Versals

Height: *18 nib widths*
Pen angle: *30˚*

A B C D E

These letterforms are constructed in the same way as those on pages 60 and 61. These decorative and elaborate letterforms were used over a long period of time, alongside many other letterstyles - usually as dropped capitals at the start of new paragraphs. Many of the letters retain the strong characteristics of Uncial letterforms.

K L M N

S T U V

F G H I J

O P Q R

W X Y Z

cannelloni
cevapcici
coq au vin
gazpacho
lasagne
linzatorte
mousaka
ossobuco
ravioli
strogo...
tort...
vol...

nātālis
beātus
nātālis
beātus
ātus
natalis
beatus
natalis

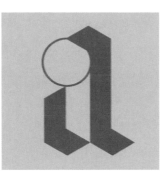

Black Letter

The first form of Gothic lettering, Black Letter is a compressed style that is written quickly and takes up little space. Black Letter evolved during the 13th century, as the need for written documents increased. Its widespread use was greatly enhanced by the development of mechanical printing techniques.

Many variations of these heavy, dense characters exist, and all mix well with other types of letterforms. The rigid geometry and simplicity of Black Letter mean that large passages of text create interesting patterns.

Medieval manuscript

A 14th-15th century manuscript, showing a tutor with his pupils, by Fra Antoni Canals. As the demand for books and manuscripts began to increase, these narrow, compressed letterforms became more widely used. This example shows clearly the characteristically even weight and texture of an overall page written in Black Letter.

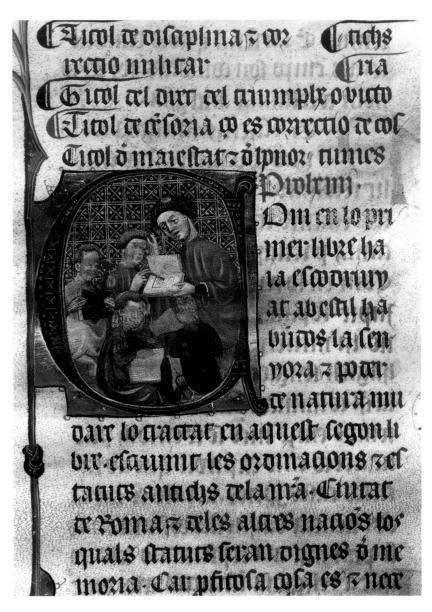

The origins of Black Letter

The term Black Letter is used to describe the first form of Gothic lettering. It was during the 12th century, while the majority of books were still written in Carolingian Minuscule, that elements of the Gothic style of compressed and angular writing first appeared in a few European countries. By the 13th century Black Letter in its various forms had become the predominant hand and was to remain so for a further 200 years. The development of a compressed letterform was the direct response to the increasing need for more written documents. Until that time, only the Church and ruling classes had commissioned written manuscripts, but almost simultaneously business, legal and educational establishments began to employ professional scribes. Literature and poetry were also gaining popularity, adding to the workload of those producing books.

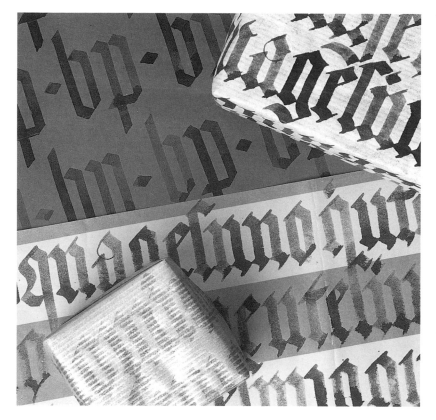

Wrapping paper

These wrapping papers illustrate some of the repeat-pattern possibilities that Black Letter offers. They were created using ink in a metal pen, but a stencil and spray paint is a good way of creating a regular and consistent pattern. The colours of different letters or rows of characters can be alternated to make a design more interesting.

Look for striped or checked papers. Not only will these give decorative results, but the lines on the paper provide guidelines for drawing the letters. Wrapping papers are available in many patterns and colours, textures and types of paper, and it is advisable to experiment with a paper before using it for a project as some do not accept ink or paint and others can absorb ink to such a degree that the letters lose shape.

Birthday card

A hand-made birthday or greetings card provides a unique, personalized alternative to a shop-bought card, and looks even better if it arrives in a matching envelope. This birthday card makes use of an unusual concertinaed landscape format with different coloured panels. The Latin words have been applied in inks with two different sized witch pens (see page 8).

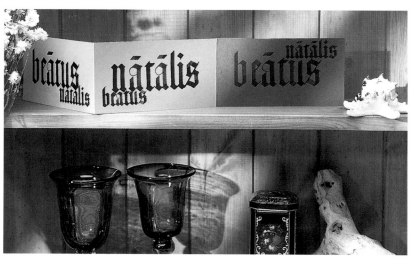

Because of its angularity and condensed character width, Black Letter could be written quickly while taking up little space. Its growing popularity was also related to the development and increased use of printing techniques, with numerous varieties of Black Letter alphabets being adopted by early European printers. Johann Gutenberg was the first European to mechanize printing with movable metal letters, and in 1450 he produced the 'Thirty-six line' Bible. So named because it contained thirty-six lines per column, this book was responsible for the extensive circulation of Black Letter type.

Tea box

On this tea box rows of Black Letter forms are contrasted with expressively drawn Uncial characters. Red, black and gold give the box a stylish image.

To create a similar box, you can adopt one of two methods. Either dismantle a box and use it as a template to make a box out of board of your choice and draw the lettering in position before cutting out the shape of the box, or measure the four sides of the box and transfer the measurements onto a piece of paper. Draw the lettering in position, then cut out the paper and wrap it around the box, securing it with double-sided tape.

This box was made from ivory board and red paper. The design incorporates four lines of lettering, each in a different language, and the block of lettering is repeated twice on each side. Each of the four lines appears at the top of one side of the box and the language of the top line is the same as the large word on that side. The lettering was applied with ink, and then the large word running vertically was made using diluted bleach. All the lettering was created with metal pens of different sizes.

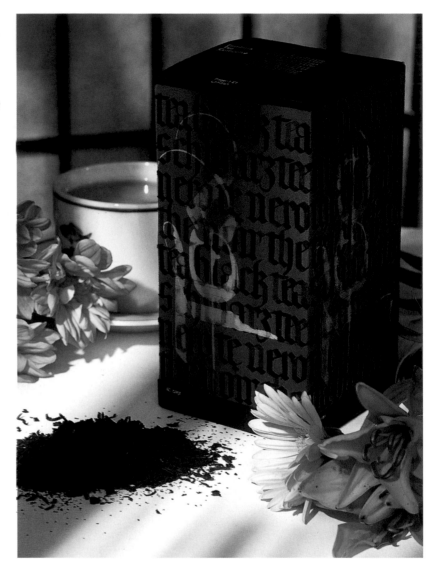

Variations on Black Letter

Gothic letterforms have been used for so long in so many countries that inevitably numerous variations now exist, and they have been adapted for use with a whole range of modern materials and techniques. You will often see examples of similar styles of Gothic lettering on shop signs, restaurant menus, beer cans and Christmas cards.

Multi-coloured letters

To produce multi-coloured letters, reload your pen with a second colour as the first is beginning to run out, before completing the letter. Alternatively, draw a letter in one shade of watercolour or ink, and then apply dabs of a second colour while the first is still wet. The two colours will merge into one another, creating stunning results.

Framed alphabet

Alphabets themselves can look interesting and attractive, whether complex or simple, if framed sympathetically. This alphabet has been split into three lines and is tightly framed. An automatic pen and gouache were used to draw the letters.

Ornamental letters

Brightly coloured, cut-out letters are easy to produce and really emphasize the dramatic shapes of Black Letter. To provide depth and balance, the counters can be highlighted. Draw the outline of the letter onto coloured or patterned paper and cut it out. If you want the cut-out letter to be decorated with smaller letters, draw the smaller letters onto the paper before you position the main letter.

Make a stencil of the letter to be cut out and move it around on the paper until you find the best position. Draw round the stencil and then cut out the letter. Mount the letter on mounting card or board using double-sided tape, and cut out the letter. Place this on a second piece of card and cut out a second letter.

In the centre of the bottom edge of the second card letter, cut a small vertical groove to take a length of thin metal rod or wire, which will provide support for the letter. Stick the two pieces of card together using double-sided tape, making sure that they match up exactly. Then attach the piece of wire so that it protrudes from the base of the letter. The wire can be bent back to make a simple stand, or it can be inserted into a wooden base, which can be painted a colour that complements the letter.

The heavy, dense characters can be used individually to create very dramatic designs. At the same time, Black Letter also mixes well with other types of letterform, particularly large capitals or free and expressive calligraphy. When you analyze these letterforms before embarking on a project, have a look at three aspects in particular. Study the effects and patterns that are created by the letterforms when a large passage of text is written in Black Letter. Consider the shapes of the individual letters and the way in which the thick strokes cover a relatively large area, allowing for experimentation within the shape of the letter itself. Then think about the counters, or spaces between the strokes. These are a similar width to the strokes themselves and therefore become just as important in the construction of the letter. This space provides another area to consider when creating your designs. Creative options are plenty. Variations on Gothic lettering, such as Fraktur and Textura, that have been used over the centuries illustrate the flourishes or split serifs added by scribes in order to liven up or decorate the letters.

Using Black Letter

Why not begin by producing a birthday or Christmas card. As you become accustomed to using Black Letter forms, apply as much colour as possible. Calligraphy immediately becomes more attractive and often communicates more effectively with the application of colour. Colour can complement the words you write. For a Christmas card, choose colours such as red, gold, green and silver that have a festive feel. Inspiration for colour is all around, and when you spot colours and combinations that you like, whether in a piece of food packaging, a shop window or the garden, note them down. At a later date, you can apply them to projects as appropriate.

CD covers

An interesting project is the redesign of CD and audio-cassette covers to personalize a music collection. This set of three CDs uses the same lettering but different coloured backgrounds. The backgrounds consist of vertical lines drawn in ink with a large metal pen, leaving very small spaces between the strokes in some places in order to recreate the effect of light catching the folds of a curtain.

The large lettering was drawn with a bleach solution using a smaller pen than for the background. Direct-transfer lettering was used for the artist and track details to contrast with the calligraphy, but you may prefer to write these in ink with a small metal nib, perhaps in an italic letterform.

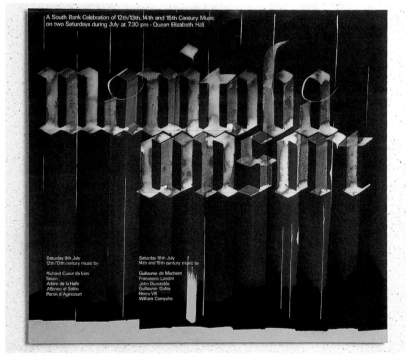

Poster

This poster was produced in exactly the same way as the CD covers, using the same lettering. The only difference is that larger pen nibs were used.

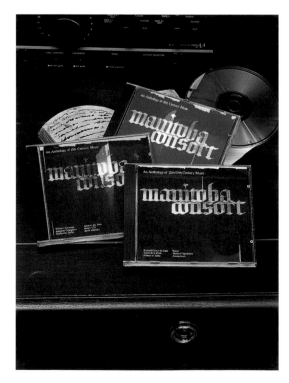

Recipe book

The lettering on this recipe-book cover was first worked out on a layout pad to make sure that the lines, including ascenders and descenders, fitted the area available. The lettering was then drawn onto a speckled and slightly textured paper in ink with an automatic pen. The paper was then wrapped around the front of the book and secured with double-sided tape. This technique can be used to liven up or personalize any book.

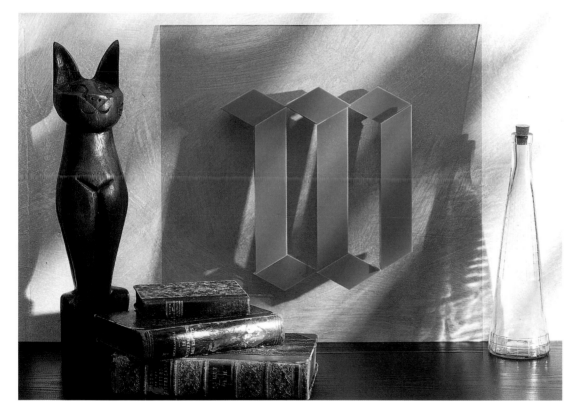

Orange 'W'

The shape of Black Letter can be explored in a three-dimensional form to create a Perspex wall decoration. The effect is made even more interesting if some faces or sides of the letter are left out as this exploits the effect of light hitting the edges of the Perspex.

If you do not have equipment for cutting Perspex, this sort of letter can easily be produced with thick card or foamboard and painted. Try painting each face of the letter a different colour to enhance the three-dimensional quality. The card or board should be fairly thick and secured with a strong glue.

As with all calligraphy, the important point is to experiment with both the letterforms and the materials and techniques that you try. Do not become too precious about your initial attempts, or be scared of making mistakes. Brilliant results often arise from initial mistakes or unintentional errors, and you will discover all sorts of interesting effects and finishes when practising on different types of paper and card and other surfaces with various media. When using Black Letter, remember that the basis of these letterforms is rigid geometry and simplicity – and this simplicity provides a good basic structure on which to elaborate with colour, materials and decorative symbols and motifs.

Stylized Black Letter
Lower case

x height: *4½ nib widths*
Pen angle: *30˚*

The regular geometric
shapes of these
letterforms, produced
from repeated elements
and angles, give them
a semi-mechanical
appearance.

The simple shapes
and consistent width
of strokes make these
letterforms ideal for
cut-out letters, and
even for stencilling
onto surfaces.

The counters are
fractionally wider than
the strokes. However,
the overall effect of a
block of text of equal
spaces and strokes
creates a regular
pattern.

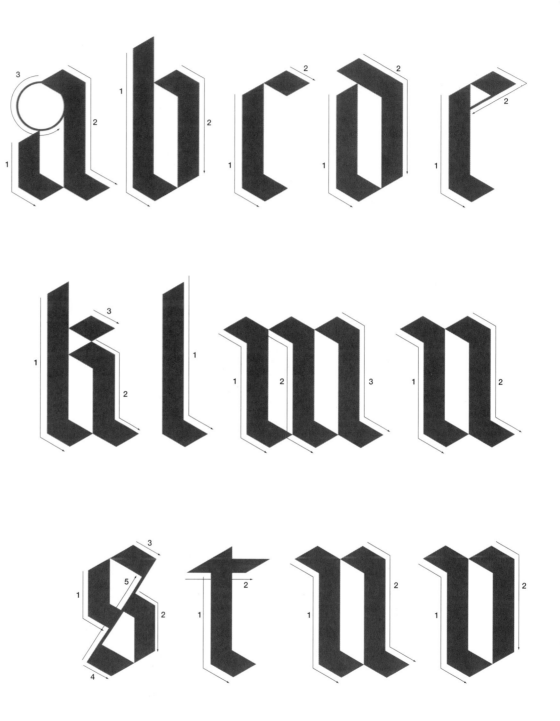

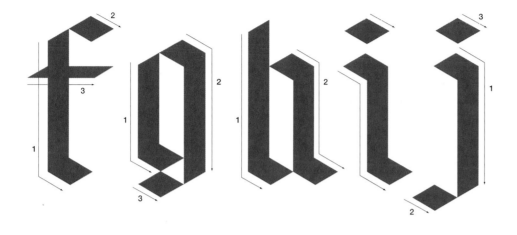

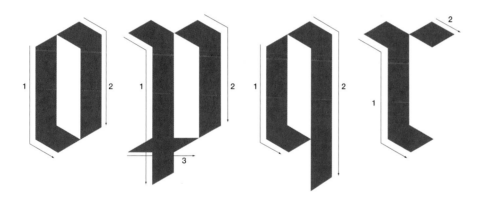

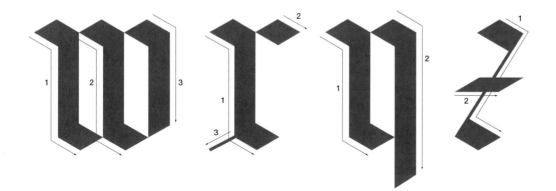

Black Letter
Upper case

Cap height: *5 nib widths*
Pen angle: *45°*

These letters are drawn with a larger pen angle than usual for Black Letter alphabets. This, combined with the distinctive double stroke on some verticals, helps to create quite a dense, black alphabet.

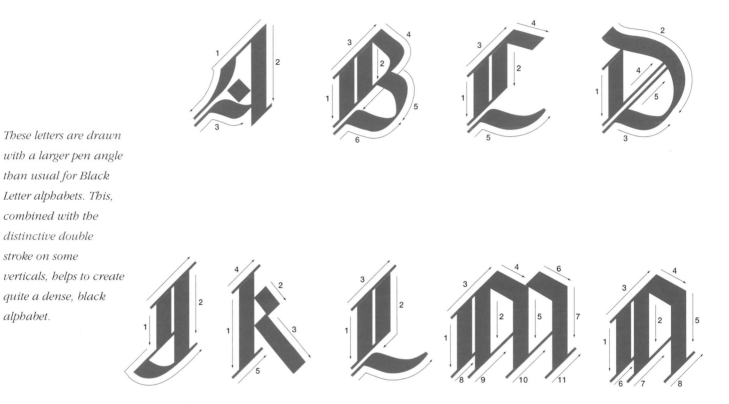

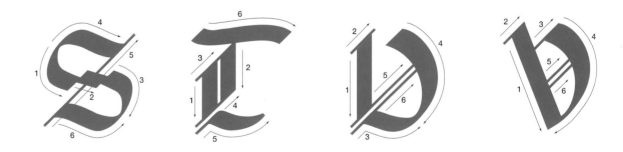

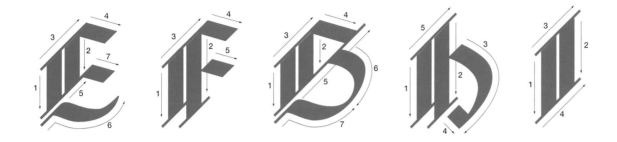

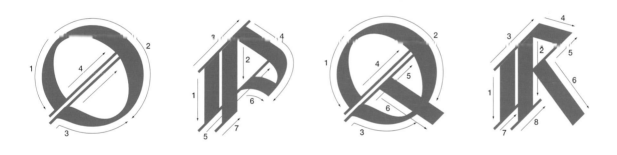

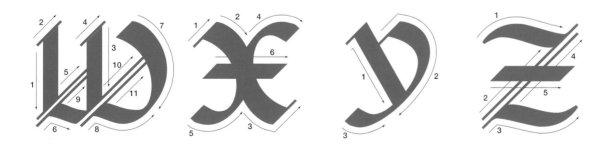

Black Letter
Lower case

x height: 5 nib widths
Pen angle: 45°

Using a pen angle of 45° produces a heavy lower-case alphabet, even though curves have been introduced to many of the letters.

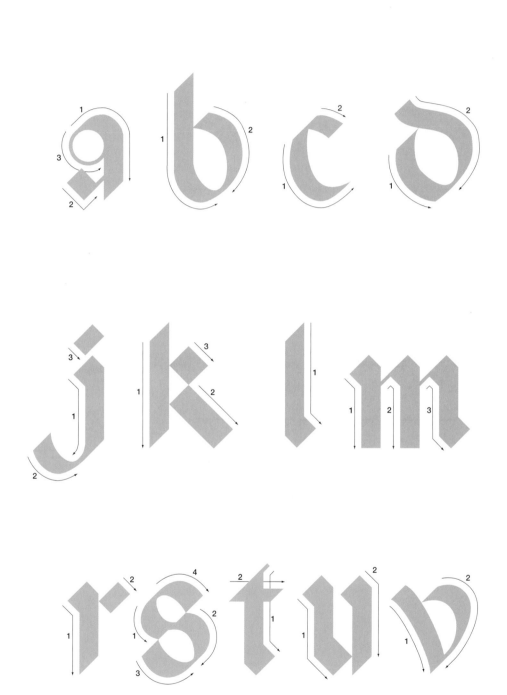

e f g h i

n o p q

w x y ʒ

Decorative Black Letter
Upper case

Cap height: *5 nib widths*
Pen angle: *30˚*

The distinctive
characteristic of this
alphabet is the use of
thin strokes, which
are drawn vertically,
horizontally and with
the pen at an angle of
30º. The space is made
for these strokes with
the further addition of
curves to most letters.

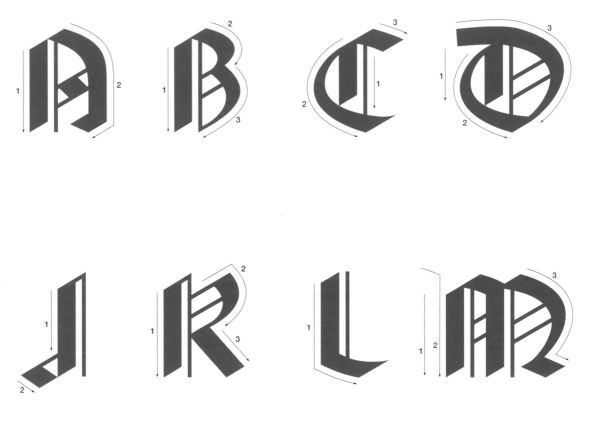

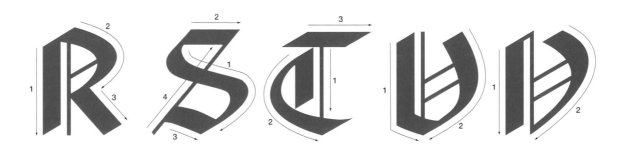

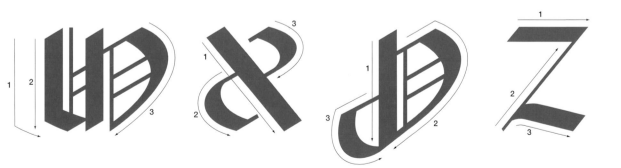

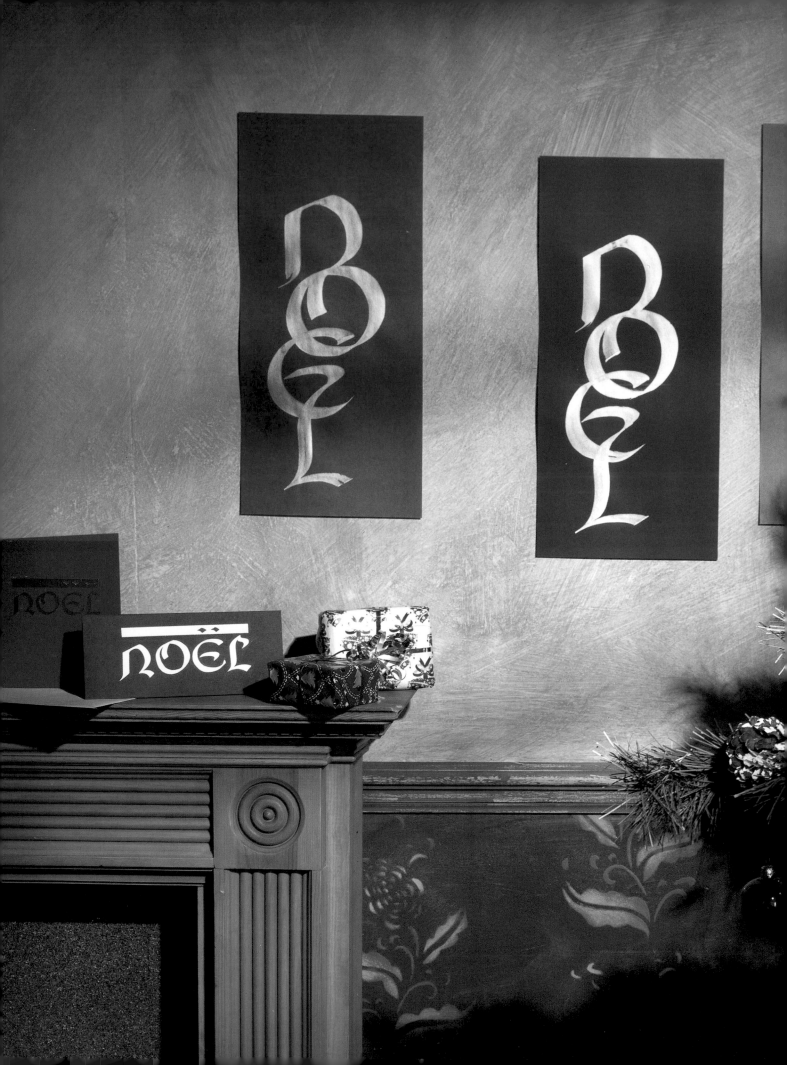

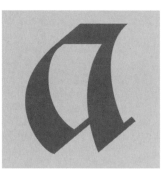

Gothic Cursive

Gothic Cursive is one of many different
forms of Gothic lettering, and probably
one of the least well known.
Based around a distinctive
almond-shaped O, these letterforms
were written quickly and spontaneously,
and with less precision than some of
the other Gothic styles.

The Book of Hours

Written in Latin on vellum, this decorative spread shows the text held between two illustrative borders. The layout is balanced by the spaces at the end of each line, which are filled in with repetitive patterns and images, painted in the same colours as the large letterforms at the beginning of each sentence.

Gothic variations

In Europe during the 13th and 14th centuries there were many different forms and variations of Gothic lettering, including Textura, Bastarda and Rotunda. Textura is the term by which northern styles of Gothic Black Letter were known, and originates from the pattern-like sense of texture provided by a page of text written in this style. This effect, accentuated by closely written letters and minimal word spacing, makes some examples virtually illegible to modern readers. These letterforms were lower case and therefore used as text scripts, although capitals were produced.

Textura Quadrata signified letterforms that had become more rigid and consistent in terms of vertical emphasis and spacing. The diamond-shaped feet and split ascenders characterize this style. As printing developed during the 15th and 16th centuries,

Textura Quadrata was to become the style adopted by the majority of printers throughout northern Europe. At roughly the same time, some scribes produced letterforms that were similar to Textura Quadrata but without feet or serifs, and this style is usually referred to as Textus Precissus.

Bastarda is the name given to less formal scripts. Many of these Gothic Cursive styles, including Littera Bastarda and Bastarda Cursive, were created by scribes to meet particular needs in education or administration. It was Renaissance scholars who applied the term Gothic to Black Letterforms, in a direct reference to the barbarian Goths, as they thought these styles visually appalling.

Cursive style

Gothic Cursive is less well known than some other Gothic alphabets, but is one of the most elegant. It can be used to great effect for headings and important information on a page of text, particularly where it is vital to catch the eye. These letterforms can be written quickly and with less precision than is employed when producing some of the more formal styles. Fluidity and spontaneity are expressed in Gothic Cursive, which is supplemented by the flourishes and curves that are drawn as letters are finished off.

The lower-case letters are based on the distinctive almond-shaped O, which is thought to have been influenced by Middle Eastern styles that were brought back to Europe after the Crusades. It is interesting to note that while the upper-case letters are upright, the lower-case forms are drawn at a very slight angle in order that text can be written more quickly and

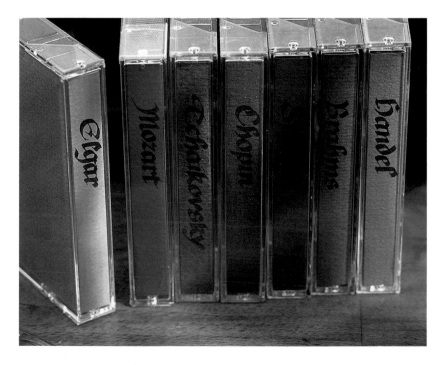

Audio-cassette covers

Audio-cassette covers can be as simple or as elaborate as you wish to make them. The spines of these covers have a minimal design for ease of use and quick recognition. Measure the dimensions of the existing covers. Compose your design on a layout pad and then transfer the design onto your chosen paper or card, working with ink, gouache or felt-tip pen.

Christmas cards
These stylish cards were made by drawing letters onto metallic gold card, cutting them out and then pasting them onto a bold, festive-coloured card.

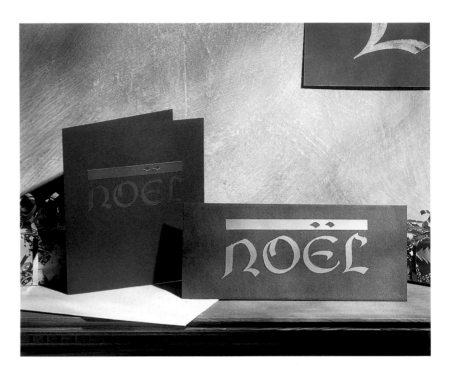

so that the letters link up more easily. This notion of employing a slight angle would later influence the development of italics and appear in much hand-lettering and calligraphy.

Applications

Gothic Cursive letterforms have a wonderful flow and elegance and seem well suited to festive and celebratory occasions. Greetings and Christmas cards are great projects for beginners to undertake. Being small-scale items, they are perfect for experimentation and can be produced relatively quickly. Not only can you have fun trying out different layouts and designs with various lettering styles, but you can also practise with several mediums. Don't neglect the shape and construction of the card either. You can produce folded or concertina cards or even cards with cut-outs and pop-ups. A visit to a card shop can prove enlightening on the variety of forms that cards now take. As you discover new shapes or folds to incorporate into your designs, your cards will take on a fresh image. To complete the project, you could make envelopes too – another ideal vehicle for your calligraphic skills. Start by ungluing an old envelope and opening it out in order to work out the shape and size of paper required. Once you are familiar with the basic envelope shape, it is easy to create more unusual envelopes.

Lettering can be created in some very unusual ways. Embroidered onto an everyday object such as a cushion – not an obvious subject for a calligraphic project – letters can look stunning. The letters are drawn onto the cushion cover and then embroidered using embroidery silks. This is a technique you might like to try out on other objects around the house.

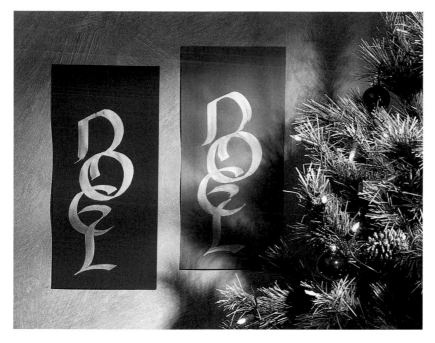

Christmas wall decorations

These simple wall decorations were made by applying the lettering in silver paint with a wide, flat paintbrush onto coloured card. The composition is made more interesting by running the words vertically and joining up or overlapping the letters. You can experiment with more elaborate designs, shapes and colour combinations for the festive holiday period.

Designs for cards

You can make many different kinds of cards. In addition to simply folding a piece of thin card in half, you could consider some of the following ideas. Whichever format or method you decide upon, check that your finished card will fit easily into a standard size envelope. You could also make a matching envelope, in which case the basic template will help you.

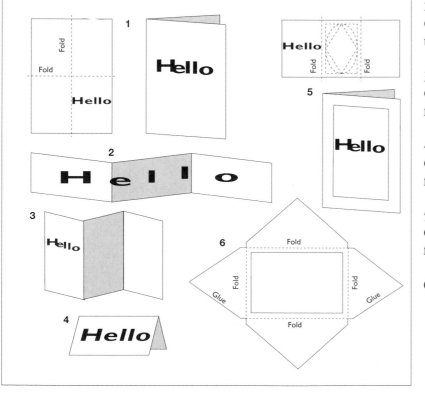

1. Folded into quarters. Useful if you do not have any thick card.
Card dimensions: 297 x 210mm (8 ½ x 11 ins) folding to 148 x 105mm (4 ¼ x 5 ½ ins).

2. Landscape concertina-folded card.
Card dimensions: 630 x 99mm (24 x 4 ins) folding to 210 x 99mm (8 x 4 ins).

3. Portrait concertina-folded card.
Card dimensions: 297 x 210mm (8 ½ x 11 ins) folding to 99 x 210mm (8 ½ x 3 ⅝ ins).

4. Landscape card.
Card dimensions: 210 x 198mm (8 ½ x 7 ½ ins) folding to 210 x 99mm (8 ½ x 3 ¼ ins).

5. Framed card.
Card dimensions: 450 x 210mm (17 x 8 ½ ins) folding to 150 x 210mm (5 ⅝ x 8 ½ ins).

6. Basic envelope template.

Gothic Cursive
Upper case

Cap height: *6 nib widths*
Pen angle: *45°*

An upright, yet flowing alphabet that can be written quickly. The strokes of Gothic Cursive are often finished off with light flourishes, curls or hairlines.

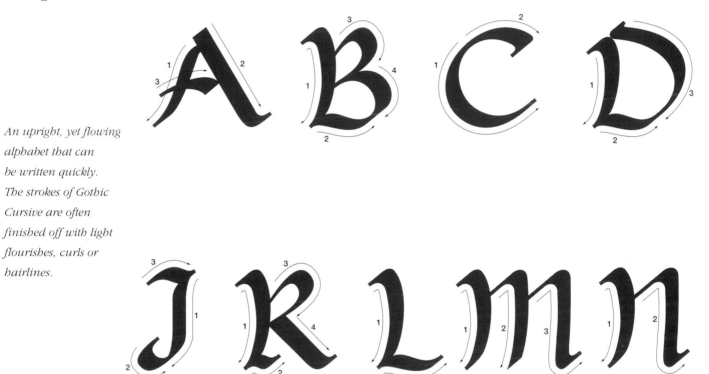

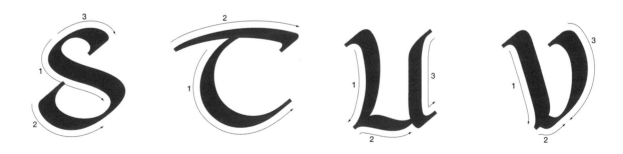

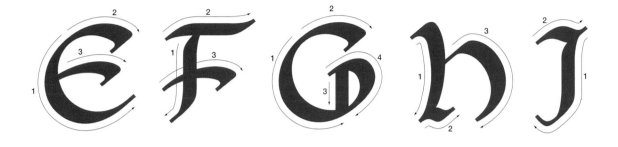

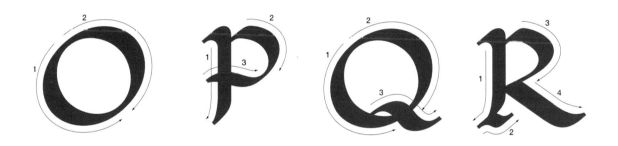

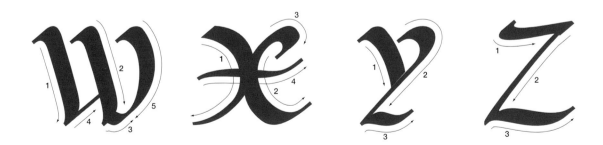

Gothic Cursive
Lower case

x height: *4 nib widths*
Pen angle: *45°*

*This alphabet is based
on the letter O, which
has an almond-shaped
counter, giving a
consistent similarity
to many of the letters.
While the flourishes
and hairlines here are
not as extravagant as
those of the upper case,
the last stroke of most
letters ends by twisting
and dragging on the
corner of your pen.*

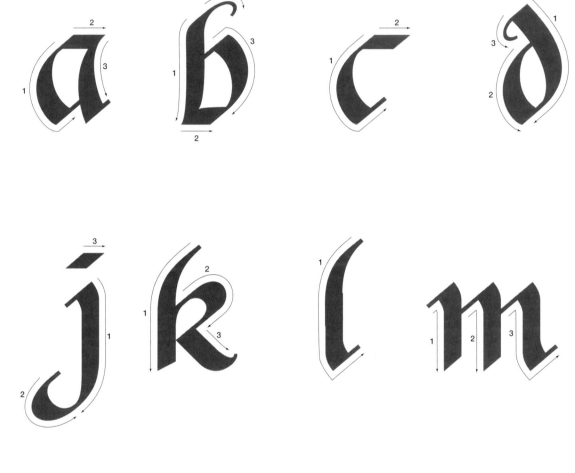

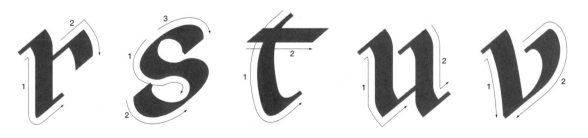

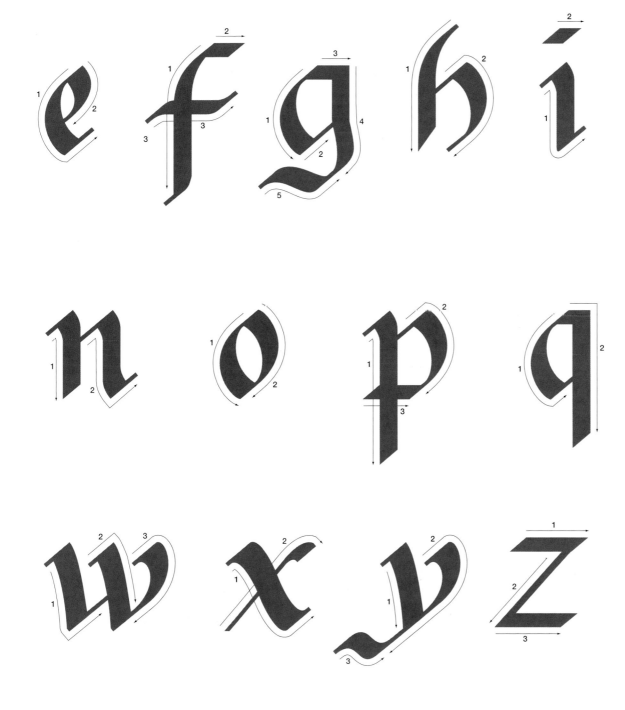

Rotunda

*Rounded and well proportioned,
these letterforms can create a rich
texture when they are employed for
an extended passage of text.
These attributes make for a legible
and pleasing style of lettering.*

Missal

This religious manuscript was produced in Milan during the 14th century. Written in Latin on vellum, it shows a Rotunda script.

Southern Gothic

Rotunda, as the name suggests, is the most open and rounded form of Gothic lettering, and is sometimes referred to as Round or Southern Gothic. Rotunda originates from areas of southern Europe, particularly Italy and Spain. As opposed to the more severe, compressed and angular Gothic styles of northern Europe, Rotunda has a well-proportioned, curved and spacious quality. While retaining the richness of Gothic lettering, these letterforms have a roundness similar to that of Carolingian Minuscule. When used for passages of text, the Rotunda letterforms provide a rich, even texture that is not over-elaborate and which works well for formal and informal designs. One advantage of Rotunda letterforms worth considering when deciding on a lettering style for a particular project is that passages of text are very legible and much more pleasing to the

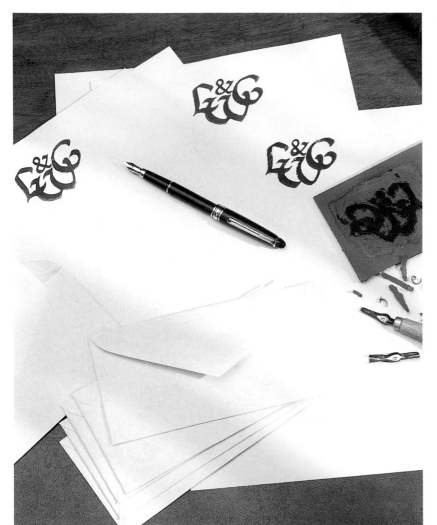

Personal logo

The formal nature of Rotunda letterforms is ideal for an individual logo, which can be made into a stamp and used to personalize stationery. This project also allows you to try out different ways of joining and overlapping your initials. Draw the letters out in different sizes on small pieces of layout paper and try different ways of combining and overlapping them until you are happy with the design.

For this stationery, the final composition was traced onto one piece of layout paper and applied to a piece of lino. The design was cut in the lino (see page 95) and the linocut was used to monogram the stationery with a selection of different coloured inks.

Letter-rack

Desk accessories such as letter-racks can provide suitable objects for lettering. In this instance, the lettering was drawn in black ink with a metal pen onto a rust-coloured, textured paper. Pieces of the lettered paper were then cut to fit each side of the rack and attached with double-sided tape. The lettering was positioned at an angle to create an interesting and unusual effect.

modern eye than some of the Gothic lettering styles that have originated from northern Europe.

The simple, clean letters of the Rotunda style need to be formed carefully in order to reproduce their pleasing shapes and proportions. It is the full and solid strokes that create the relatively heavy tone, without hindering legibility. This strong, compact, readable quality can partly be accounted for by the fact that the characters are uncluttered by elaborate serifs or finishing strokes. You can, of course, add improvised flourishes and elongated serifs to certain letters in order to build up a more interesting overall design or to fill awkward spaces. If you want to do this, plan these additional elements once you have worked out the main structure and composition of the project.

Ring binder

The unusual washed-out effect of these letters is a direct result of the material that the ring binder is made from. When the black ink was applied with an automatic pen, certain areas accepted or resisted the ink more than others, leaving different depths of ink within parts of each letter.

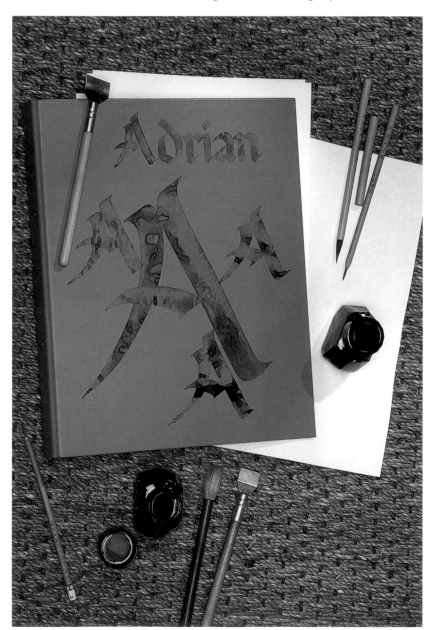

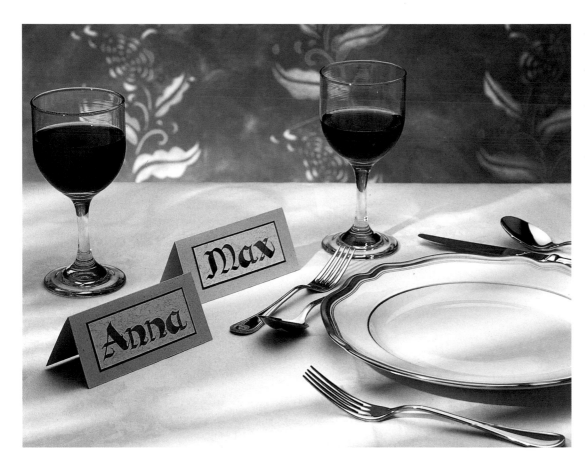

Place-cards

If you enjoy having friends around for a meal, why not produce some place-cards for the dining-table. They can provide a formal touch in the event of a special occasion. For the place-cards illustrated here, a thin and a thick pen were used, giving a certain emphasis to the individual letters and an overall balance to the words.

Using different coloured inks for each name, draw them out on white paper. Cut out the names and paste each to a different coloured card. You could try different designs for different events, such as birthdays and anniversaries.

Lino-printing

Lino-printing is great fun and the necessary equipment is inexpensive and readily available from most art shops. Work out the composition, and then draw out the letters on a layout pad. Trace the design onto a small piece of lino. Remember to transfer the reverse or mirror image onto the lino so that when it is printed it appears the correct way round. You can either cut away the background, leaving the letters raised, or cut away the letters and print the background. With the latter method you can embellish the design by cutting illustrative motifs or images into the background. You can print the image with a number of different mediums. Drawing inks work very well, and can be applied to the stamp with a brush or by using an ink pad, which automatically provides even coverage.

Some wonderful effects can be created using linoprints. If you look closely at your results, you will see that usually the letters are not absolutely crisp or clean, but have a slightly fragmented quality. This can be made more pronounced by printing onto a heavy watercolour paper. The size of a design is limited only by the dimensions of the piece of lino, so if you enjoy this technique you can print large-scale designs using large pieces of lino.

Another possibility is to use a combination of mediums. You could, for example, supplement the design after the linoprint has dried by adding freehand images or shapes using watercolour or gouache.

Rotunda
Upper case

Cap height: *5 nib widths*
Pen angle: *45˚*

These upper case letterforms are very open, almost expanded, with plenty of space within the counters and bowls of the letters.

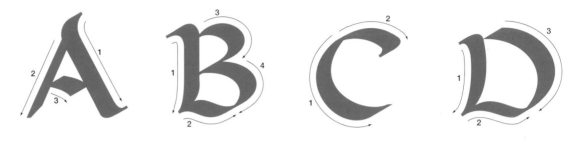

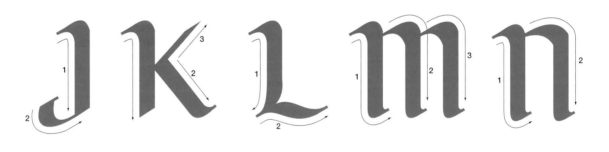

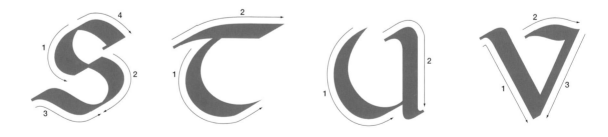

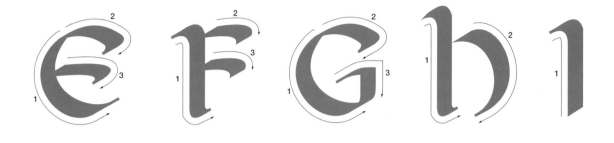

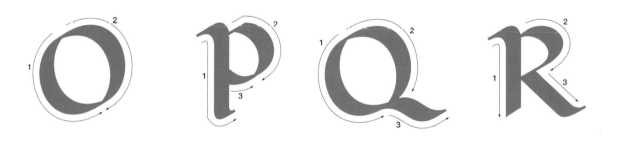

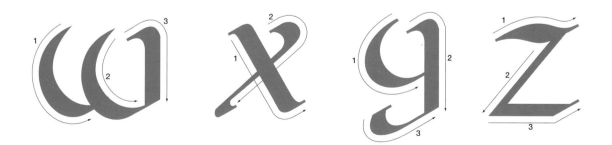

Rotunda
Lower case

x height: *4 nib widths*
Pen angle: *30°*

The high legibility of
the lower case Rotunda
alphabet is partly due
to the large counters
and bowls, and is also
contributed to by the
lack of flourishes. Each
letter has neat, clean
ends to all strokes.

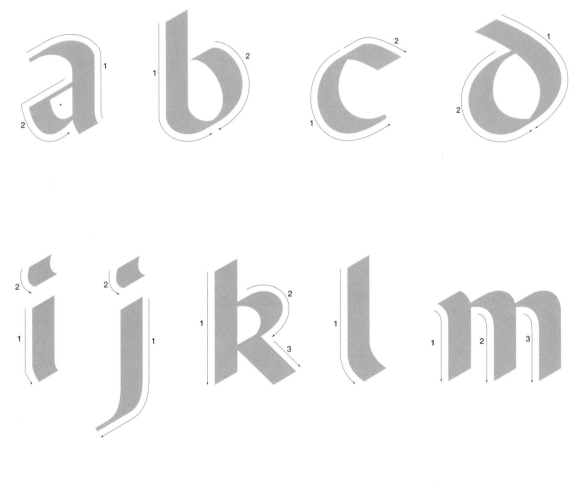

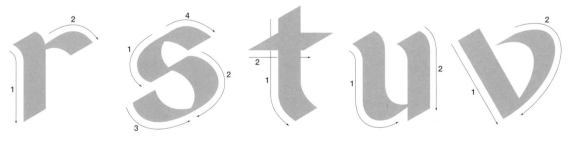

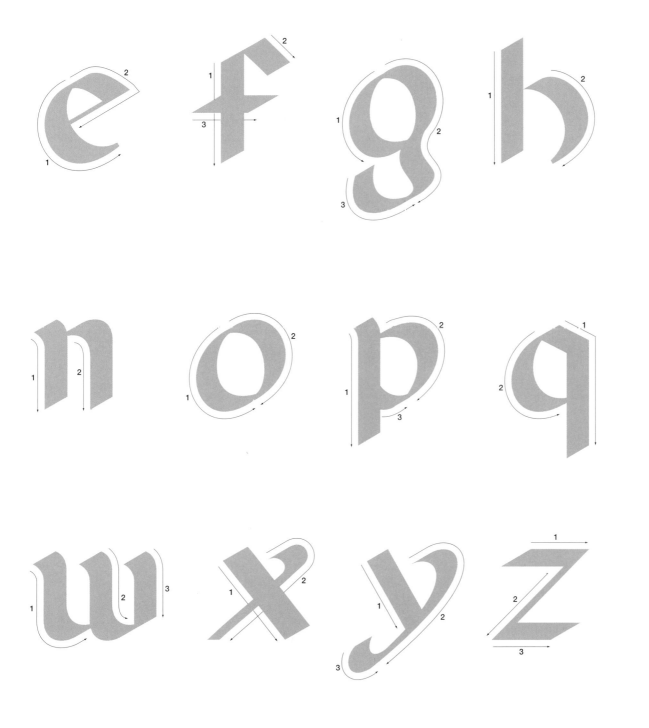

Italics

*If calligraphy and decorative lettering
are new interests for you, italics are
one of the best styles of lettering with
which to start.
The letters are easily formed, can be
written or drawn quickly, and look elegant.
In addition, italics are ideally suited to
embellishment with flourishes and hairline
finishes, allowing you to design individual
pieces of lettering.*

Investiture

An act of investiture bestowing on Pietro Banarelli of Ancona, the castle of Orceano, the title of count and other privileges.
The lettering on the left is based on Roman capitals, while the text on the right is written in italic script in Latin.

A handwriting script

Elegant and spontaneous, with a consistent rhythm, italic letterforms are used today in all kinds of settings. This well-known and widely used style of lettering originated in Renaissance Italy. The very beginnings of an italic script were produced by the scribe, Niccolo Niccoli, around 1400. Using the informal Gothic Cursive letterforms as a starting point for the minuscule script and Roman forms for the capitals, Niccoli gave all his lettering a slant. This style of lettering became the standard one for copying classical texts, and was quickly adopted throughout Italy.

As the use of printing spread across Europe during the second half of the 15th century, scribes were no longer needed for copying standard texts and the amount of work declined.

Menu
On this menu the lettering is centred, and the use of a capital M would normally weight the design heavily on the left-hand side. However, the introduction of two large, flourished strokes helps the lettering to sit more easily within the area and improves the balance of the design.

Plant cards
Those who have house-plants might like to make cards recording the plant's name together with instructions for looking after it. Simple italic letterforms were drawn in dark blue ink with a fountain pen onto thick card. The cards were then cut to shape and covered with transparent self-adhesive plastic to protect them from the damp soil.

However, through the production and distribution of printed books more people became literate, with the result that more people wanted to be able to write, and handwriting became more common in everyday life. Some professional scribes therefore turned their hands to teaching people to write, using the italic script, and were therefore able to remain in employment.

Storage box

A storage box can quickly be made more attractive by adding labels made with interesting lettering. The lettering here was drawn in various coloured inks with a metal pen onto paper, then cut out and glued to the front of the drawers.

Gift bags

Gift bags can be personalized with a few well-chosen words. Silver metallic ink was used on these otherwise plain gift bags in order to brighten them up.

Italic lettering combines easily formed characters that can be written quickly with good legibility. The serifs are simple and the ascenders and descenders can be varied in length. Flourishes and elaboration are easy to add on most of the letters. Italic letterforms work well in many different circumstances, and seem just as appropriate in both formal and informal situations. Italic letterstyles can be adapted in different ways and lend themselves to being condensed and expanded, as well as to variations in the stroke width, so do not be afraid to experiment at will. Italic alphabets are a good style of lettering for beginners to practise on.

Adding a flourish

Of all the hand-drawn letterstyles employed through the ages, the italic form is probably the best suited to long, extravagant flourishes, and it is worth spending time on creating and practising finishing strokes. As you can create your own

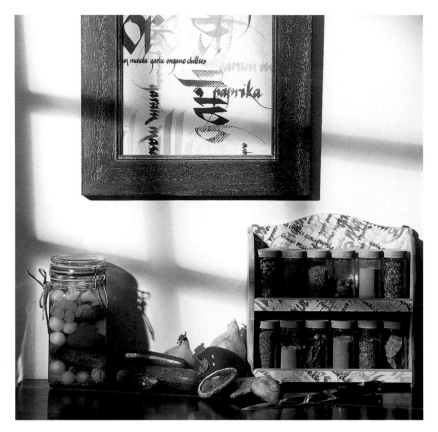

Spice rack
A spice rack may not be the place you would normally expect to find expressive lettering, but it creates a colourful surprise in a kitchen. The slightly transparent quality of some drawing inks is used to good effect as the shapes and colours that can be created by overlapping different-sized lettering drawn at varying angles with different coloured inks is quite stunning. The lettering was drawn onto a heavily textured paper, thus giving some of the letters a slightly broken form. The paper was then cut to shape and glued to the wooden rack (see page 38).

individual details and motifs, the design possibilities are endless. In some cases, for example, it may be appropriate to balance a piece of italic lettering with a separate swirl or design drawn with the same pen and medium at the base of the page.

Preparing wood surfaces

Furniture and household items picked up at junk shops and car boot (garage) sales can provide wonderful surfaces for calligraphy, as do plain untreated pieces of wooden furniture. If you are familiar with applying paint effects and designs to pieces of furniture you will realize the potential that hand-drawn lettering can have, whether used as a small detail or a major design, and tables, cupboards and drawers provide plenty of flat surfaces on which to apply your creations. Whether you are going to work on an old or new piece of furniture, make sure you prepare the surface well by sanding and priming it, and applying an undercoat and top coat of paint. Your confidence may be such that you can draw italic letterforms straight onto the surface. If not, roughly mark out the letters with chalk first. Obviously this is calligraphy on a large scale, and depending on what paints you are using a coat of varnish may be required to protect the paint work.

You do not have to apply the lettering straight onto the surface of furniture in order to create stylish results. If you are happier working with pens and inks on paper and card, you can apply cut-out lettering to pieces of furniture using the découpage technique (see page 23).

Expanded italics
Upper case

Cap height: *10 nib widths*
Pen angle: *45˚*
Letter slant: *10˚*

The elegant contrast between thicks and thins is produced by holding the pen at an angle of 45˚.

Serifs can be drawn as part of the main stroke, or as a second, separate stroke.

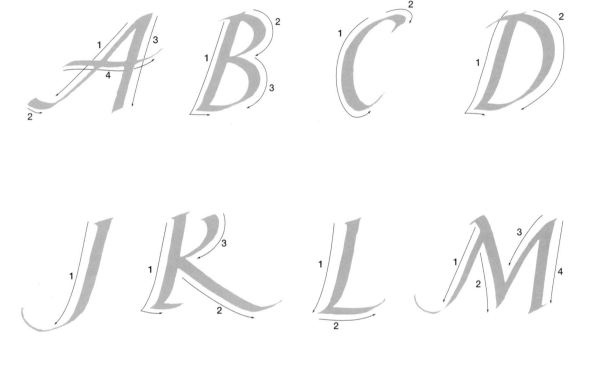

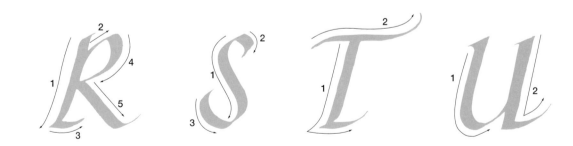

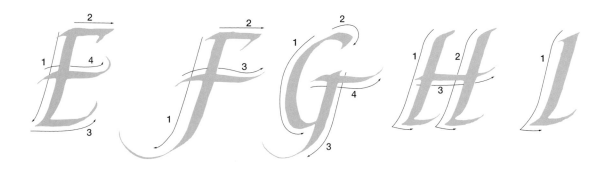

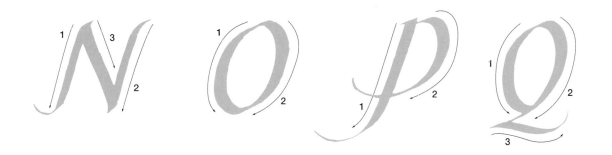

Expanded italics
Lower case

x height: *6 nib widths*
Pen angle: *45˚*
Letter slant: *10˚*

Italic alphabets provide a good starting point for learning calligraphy. They can be written quickly, and the ascenders and descenders are ideal for elaboration with flourishes and stroke extensions.

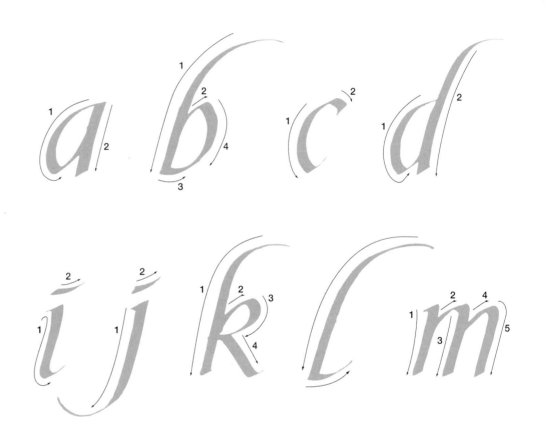

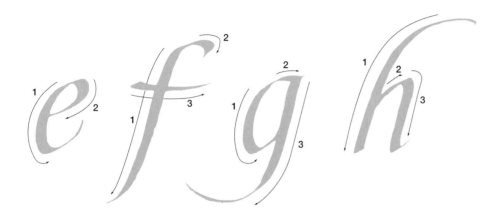

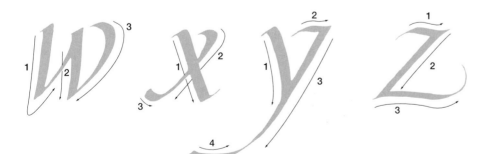

Italics
Upper case

Cap height: *12 nib widths*
Pen angle: *45°*
Letter slant: *10°*

Italic letterforms are based on an elliptical O. When drawing these letters watch the spaces in between the letters carefully, ensuring that the spacing remains visually equal.

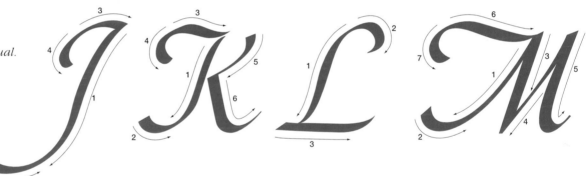

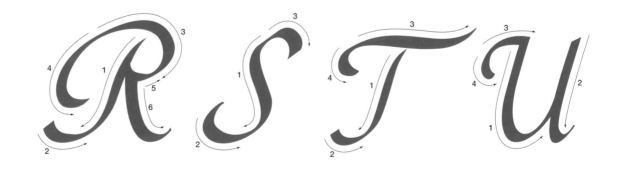

Italics
Lower case

x height: *8 nib widths*
Pen angle: *45°*
Letter slant: *10°*

Italic letterforms, when spaced correctly, provide a regular rhythm, allowing the flowing ascenders and descenders to embellish the lettering.

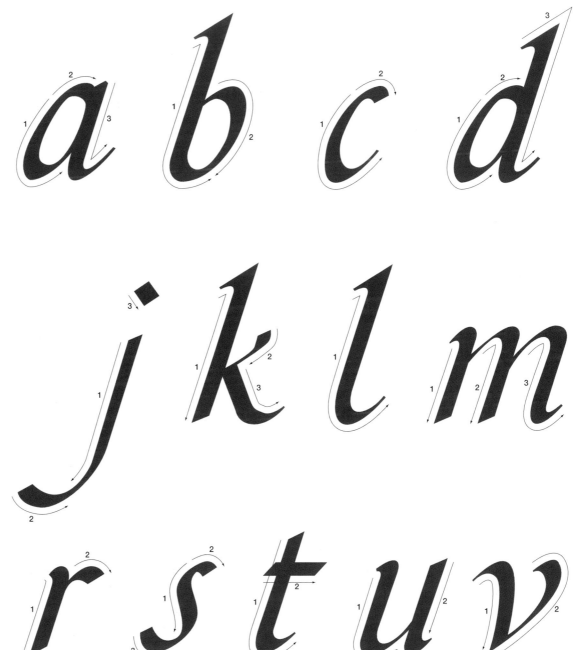

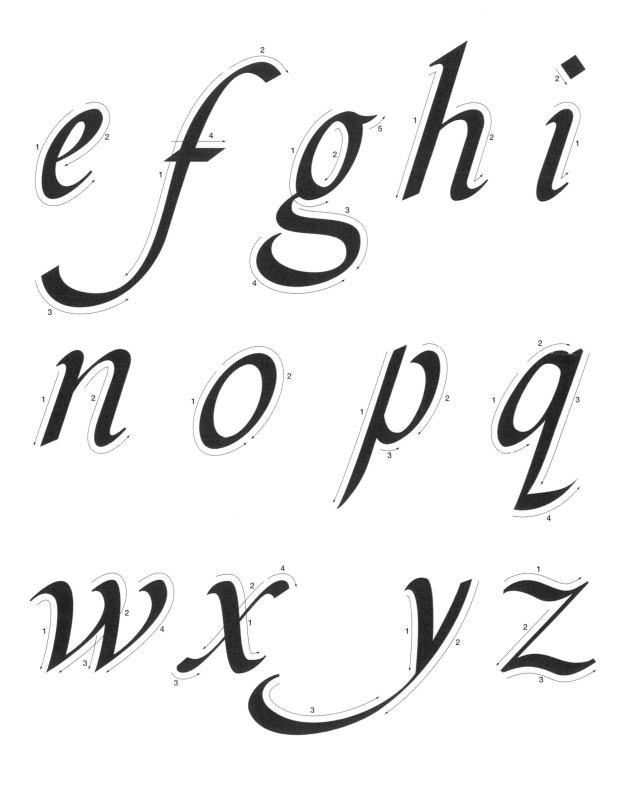

Contemporary Letters

*Modern and contemporary lettering
allow for numerous styles of design
and the use of modern materials.
With all the alphabets and letter styles
produced through the ages to look at for
reference and inspiration, and with the
continual production of new writing
implements and mediums, there are few
limitations on what you can do.*

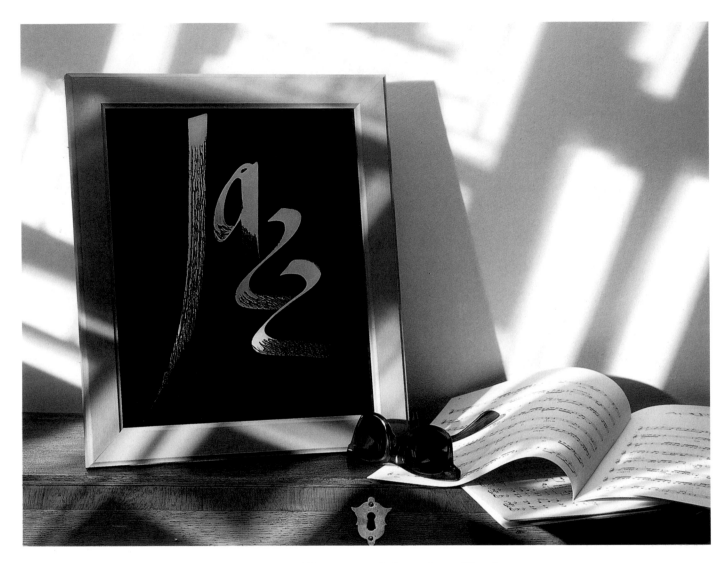

Jazz poster

This simple piece of lettering was created using acrylic paint and a large, relatively coarse, flat brush. Interesting textures were formed towards the end of each stroke as the paint began to run out. The texture is accentuated by using black and white, which form a strong contrast.

New materials and applications

The term 'contemporary calligraphy' covers all hand-drawn lettering designed in the 20th century and includes a great variety of styles, some of which involve the use of materials that were not available in the past. Human ingenuity and the continuing appetite for new technology is responsible for providing us with all sorts of materials with which to experiment. For example, multiple-stroke pens can now be used to give a patterned quality to classical or medieval characters, and the Perspex Black Letter W on page 71 is made entirely from plastic.

Each project should be dictated, to some extent, by what the particular words or letters demand. In some instances, successful contemporary calligraphy is about finding the correct mixture of old and new. Contemporary calligraphy is often based on one of the lettering styles already discussed, and it is important to study these styles in order to learn the principles involved and the effects that can be created. Having become

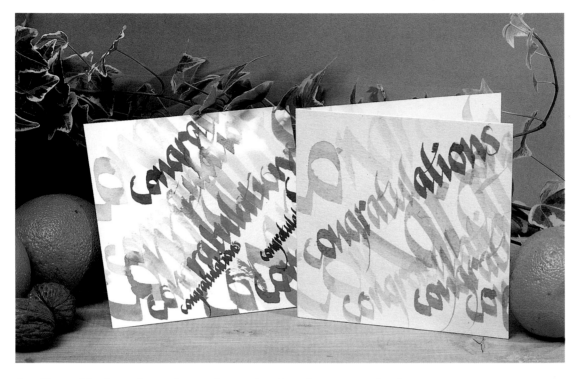

familiar with these letterforms through using them, your freely drawn experiments should be much more successful. For example, it is important to learn about the proportions of letters, the order of strokes for making them, legibility, weight of stroke, positive and negative space, letter and word spacing, contrast between thicks and thins, and so on. Essentially, though, modern calligraphy should bring something new, something of our own time, to the letterforms.

Developing your own letterforms

There are 26 letters in the alphabet, in both upper-case and lower-case forms, at your disposal. It is the skeleton of these letters that can be adapted, built upon or elaborated. The wonderful shapes that exist within letters and the effects that can be created by manipulating these forms are fascinating, with different mediums broadening the range of possibilities. Start off by trying to impart a new accent or image to a traditional alphabet. A drawn alphabet framed and mounted on the wall will sit well in a study, hall or lounge. Practise on layout paper, and each time you draw out an alphabet, new ideas will occur to you. Perhaps try slightly changing the spacing between letters, modifying the length of an ascender or varying the thickness of different strokes. When you understand the basic principles, the possibilities for using lettering are almost endless.

Another way to modify a traditional alphabet is by using split or multi-tipped pens, which are available in a variety of widths. These modern dip pens can give lettering an added dimension or extra effect. Alternatively, to create a slightly different effect,

Congratulations cards

To create an interesting design and texture on these congratulations cards, various green and blue inks have been diluted to different strengths. By combining different-sized letters drawn in different strengths of ink and overlapping them slightly, a depth is given to the lettering, making it look as if it is on separate layers. It is advisable to draw the lettering on a large piece of card and then cut and fold it into a card shape. In this way the lettering will cover both the front and back of the card, and you can choose the best area of lettering for the front.

Framed alphabet

This alphabet fits well into a diamond shape. This was not the original intention, however, but developed from drawing and refining the design many times. The extended stroke on the J and the extension on the O help to balance the design and allow it to sit well within the frame. Originally drawn with a felt-tip pen, the final version was enlarged on a photocopier and then copied onto red paper. Interesting characteristics of pen and brush lettering can be highlighted and accentuated by enlarging on a photocopier, and now that colour copying is available you are not confined to black and white.

you could experiment by drawing letters with individually-made double strokes, creating characters with two parts to some strokes (on the verticals, maybe), while other parts of the letter are made with single strokes. Taking this idea one stage further, you could experiment with letterforms drawn using two pens of different widths (see the place-cards on page 95). These experiments lend themselves better to capital letters, not just because capitals are larger, but also because of their placement on a page – usually as a title or heading. If, however, a particular project requires a single word written entirely in capitals, you may discover some interesting ways of employing double strokes to link or join the letters. It might even be appropriate to combine two or more variations on double-stroke letters within a single design. Be careful not to overdo it, however, as over-embellishment can overwhelm a design rather than complement it. Do not forget the reader, either. Legibility dictates that single

words can be exaggerated or embellished much more easily than passages of text.

If you expand, condense, italicize or embolden a traditional alphabet, you can create new letterforms. Through expanding or condensing a letter by different amounts, you will also discover the extremes to which you can reasonably push each letter. The same applies to italicizing and making bolder: if these are taken to the extreme, the letters will look absurd.

You can alter the appearance of a block of lettering by adding a shadow or by superimposing layers of letters one on top of another at different angles. Transparent inks are good for this, as they enable you to build up a rich texture of different colours while still allowing previous layers to be read. The congratulations card shows both an interesting use of transparent inks and the way in which the individual elements of different-sized words contribute to the overall appearance. When trying this technique, keep an eye on the overall tone and texture of the design as it is easy to go too far. Regularly stand back from your lettering in order to assess which areas are working effectively and which need more building up.

One of the simplest ways to develop or elaborate on an existing letterform is to add a swash or hairline flourish to suit the particular design. The picture frame shows precisely how the space available, or an object's shape, can dictate the lettering shape and style. Flourishes are used to extend or terminate a stroke and can be made into curls or loops depending on

Lowry picture frame

This picture frame illustrates how to make use of limited space. When attempting to apply lettering to an object such as this it is advisable to draw the shape of the object on a piece of paper. Use this as a guide beneath your layout paper when working out the composition. When you are happy with the design you can recreate it on the object.

Letters were applied to the frame using matt enamel paint and a flat paintbrush. The frame can be sealed with one or two coats of varnish when the paint is dry.

It can be difficult to find a comfortable position for your writing hand when applying lettering to an object. In this instance, a book was butted up against the lower edge of the frame, forming a flat, even surface on which to rest the hand.

Chess and draughts (checkers) board

A home-made board for playing chess or draughts (checkers) is relatively simple to produce and offers an interesting item to decorate. The design of this board was first worked out on a layout pad. Notice how the letters are formed within the squares while the flourishes extend freely across them. The squares were measured and drawn out in pencil on thick red card that had already been glued to a piece of thick cardboard. The black squares were filled in using black ink with a flat paintbrush. The lettering was then drawn with a metal-tip pen in a bleach solution (see page 135). A relatively small pen was used so that the strokes of the letters are quite thin and wispy, allowing the background squares to show clearly.

their length. Remember that to achieve a smooth flow, you should produce flourishes quickly by twisting and lifting the pen at the same time (see page 21). A few minutes practice can produce enthralling results. On large-scale pieces you could place a number of flourishes throughout the design to add rhythm or to assist the eye when reading the lettering.

The third dimension

The three-dimensional possibilities of lettering are also worth exploring. The orange W on page 71 is a prime example. The success of three-dimensional letters lies in studying the construction of the letterform very carefully, and in most cases involves stylizing or modifying it. A similar challenge lies in producing cut-out letters that hold together and remain legible.

An alphabet mobile can be made using a relatively simple, compact letterstyle, but careful positioning of the thicks and thins is required in order to balance the letters so that they hang correctly. Careful attention also needs to be given to the balance

of the internal space in the counters. Flourished or extended strokes are almost impossible to make in cut-out form, so if you like the idea of a mobile but want to use more elaborate letterforms, draw the letters on card and then cut them out as circles, squares and triangles that accommodate any extended flourishes and finishing strokes. You could also apply different letters on the reverse of the cut-out shapes.

Cutting out letters

Cut-out letters can be used for découpage onto objects, creating mobiles or even free-standing lettering. Care must be given to the letters you choose or design to be cut out. The easiest letters to cut out are those with solid, intact counters and bowls. They are stronger because there are no thin spots where the strokes meet. The counters and bowls can then be filled in with a pattern or different colour (see page 119).

If the counters and bowls are also to be cut out, the design of the letters is crucial. Make sure that the weak points, where the strokes of the letter meet, are as thick as possible. A good example of this is the alphabet on pages 122-123.

Place-mats and coasters

Place-mats and coasters decorated with the initials of family or friends are a welcome sight at the dinner table. Plain cork mats in various shapes and sizes are readily available and provide an interesting surface for lettering. These letters were drawn with a large, flat, felt-tip pen. Because of the slight indentations in the cork, the flat felt-tip pen left small uncovered areas, which were filled in with a smaller pen of the same colour. Two coats of clear varnish were applied to seal the mats, making them easy to wipe clean.

Contemporary letters
Upper case

Cap height: *12 nib widths*
Pen angle: *45°*

These flowing and free-looking letterforms are ideal for headings and display lettering. Most of the thick, solid strokes are usually finished with a small hairline, created by a slight turn of the pen as it is lifted from the writing surface.

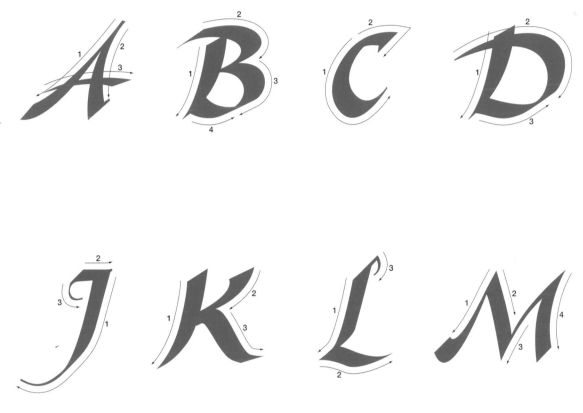

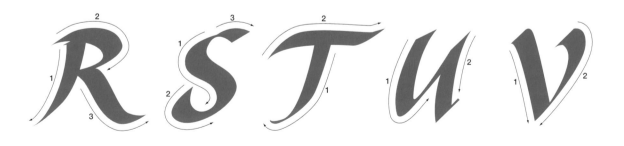

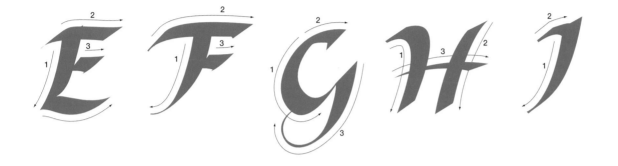

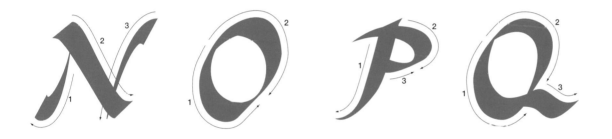

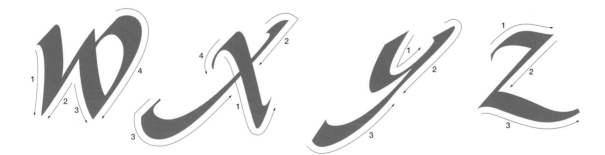

Contemporary letters
Lower case

x height: 3½ *nib widths*
Pen angle: 45˚

This alphabet is based on lower-case book-hand letterforms. The relatively heavy proportions are produced by combining a wide nib with a short letter height. There are no hairlines or extravagant thin flourishes, but there are controlled small serifs on some letters, such as m, n, r, u, v, w and x. Large metal or automatic pens are ideal for constructing these letters.

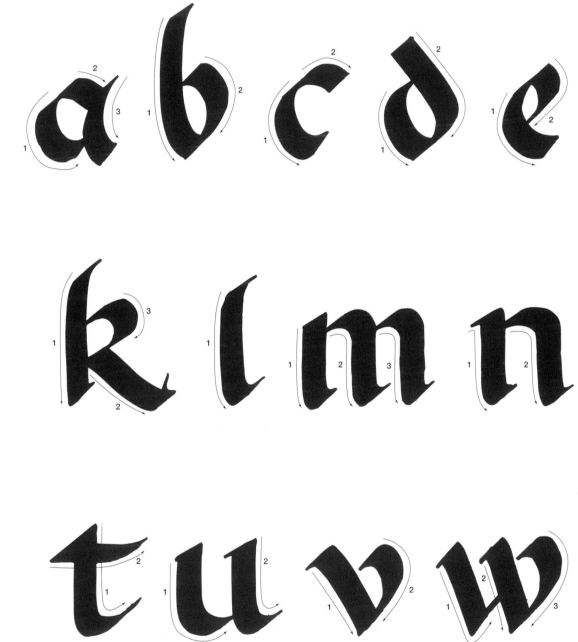

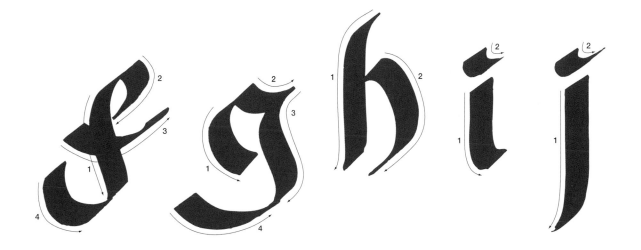

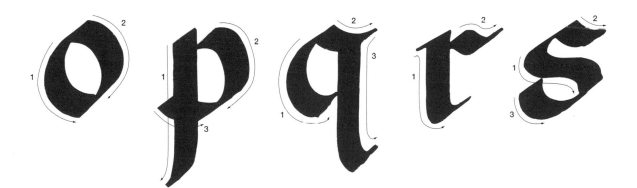

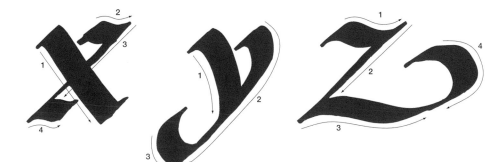

Contemporary letters
Lower case

x height: *3 nib widths*
Pen angle: *45°*

This alphabet displays
heavily contrasting
thicks and thins. All
the thins are created by
twisting the metal pen
onto its corner and
drawing relatively
long, almost flourished
strokes.

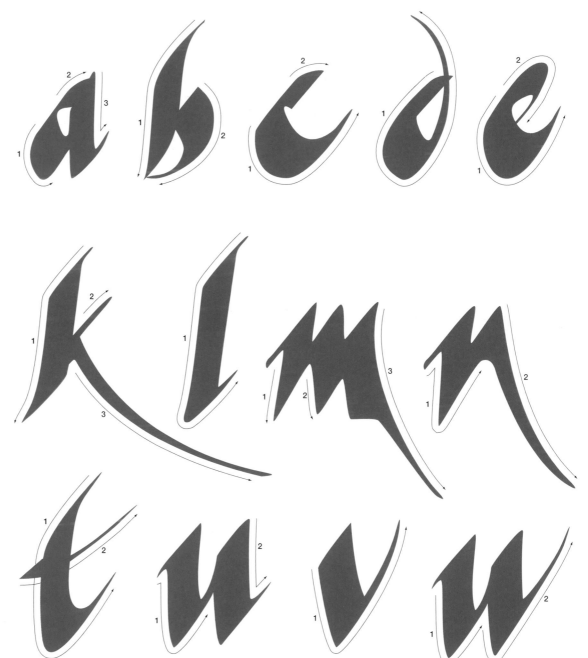

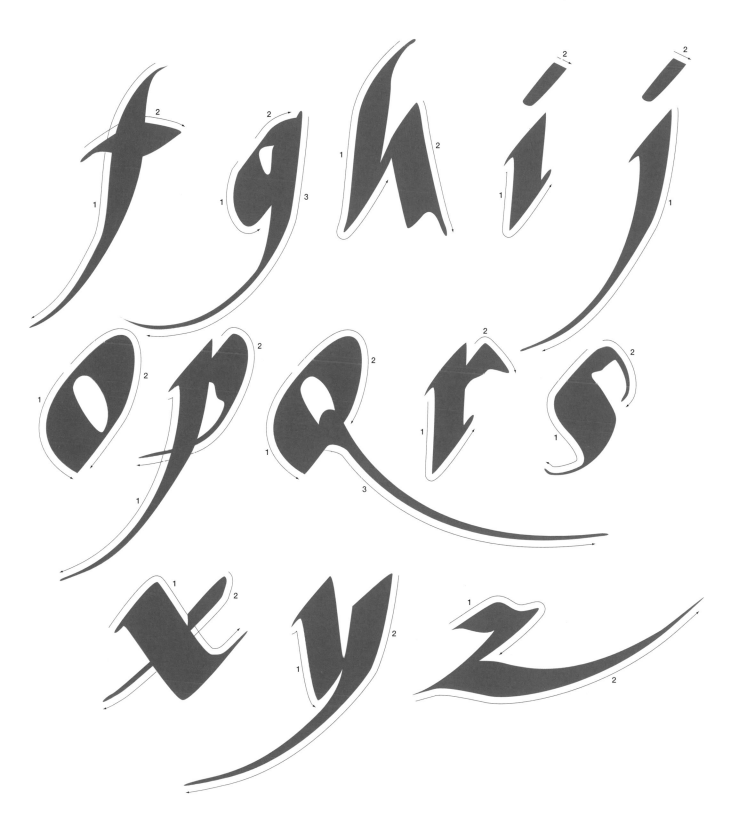

Contemporary letters
Lower case

x height: *4 nib widths*
Pen angle: *45°*

These modern letterforms were written quickly with a brush. You may like to try drawing these letters with a two-pronged metal pen, leaving a gap in each stroke that can be filled in with another colour, or left empty for the writing surface to show through.

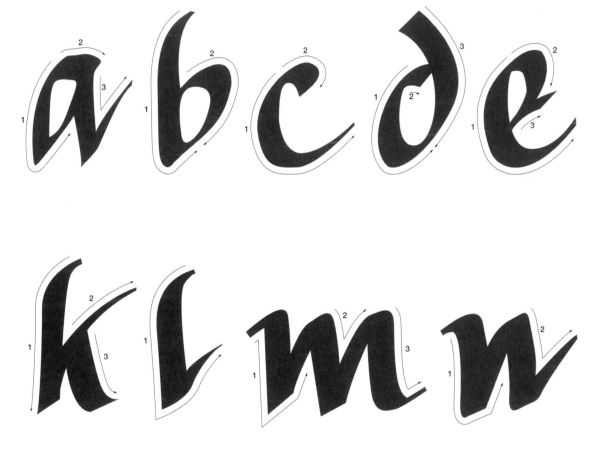

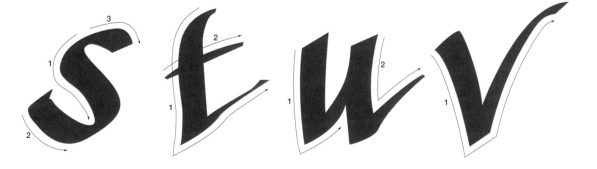

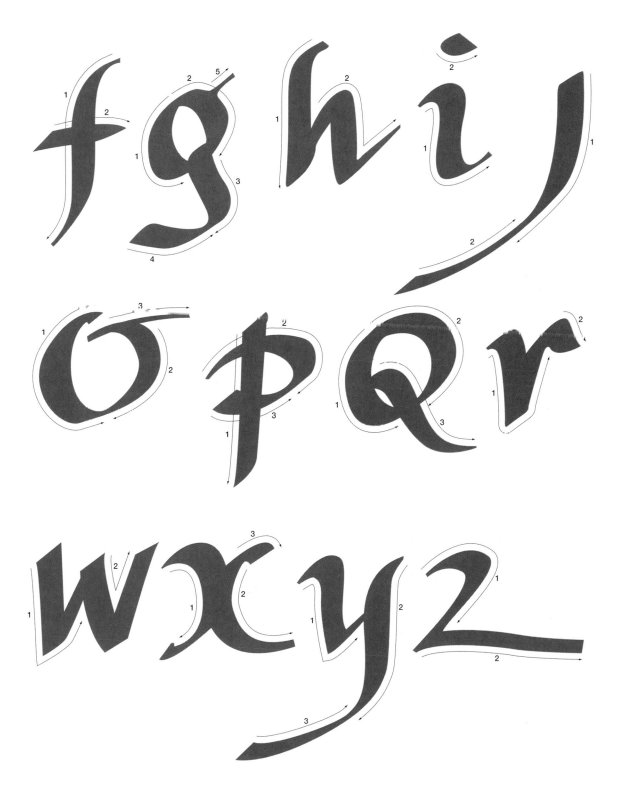

Numerals

*Often neglected, numerals provide
ten more characters to use creatively,
decoratively and imaginatively.
Although usually simpler in construction
than letters, balance and spacing are
just as important with numerals.*

***Numerals in the
16th century***
*Both numbers
and Roman
numerals have
been used
alongside each
other on this
astrolabe
produced by
Thomas Gemini
in 1552.*

Combining numerals and letterforms

Numerals are included here partly because they seem to be
neglected in other books and, more importantly, because you
will probably have many ideas for projects in which numerals
occur. When a modern typeface is designed, the font usually
holds upper-case and lower-case letters as well as punctuation
marks and numbers. So why overlook numerals, especially as
they also provide ten more shapes to be explored?

Because numerals originated from Arabic letterforms rather
than Roman (the Romans used numbers for dates and figures),
they look different from both lower-case and upper-case forms.
Furthermore, the elements that make up numerals differ from
those of letters. These facts help to explain why numerals can
look strangely out of place if they are not in the same style as
lettering displayed alongside them.

Playing cards

Playing cards can be fun to design and make. You can cover the faces of an existing pack with pieces of thin card to provide space for your own numerals and symbols, or you can draw your numerals and symbols on pieces of white card and back these with patterned or coloured paper.

The numerals on these cards were drawn with a metal pen using black and red inks, and the symbols were applied with a small paintbrush. You may find it easier to create a stencil for the symbols.

The cards can be covered with transparent, adhesive-backed plastic, trimmed to size, to make them more durable.

Many people hold the misconception that numerals should match the height of any capitals that they are used with. Yet if you study typefaces in books and newspapers, you will probably notice that, just like lower-case letters, numerals frequently vary in height, and that many have ascenders and descenders. There are situations when numerals occurring within a line of capitals should be the same height as the capitals, because otherwise the balance of the line would be spoiled. However, the legibility of numerals can be increased by giving them ascenders and descenders, and the overall effect provides a pleasing contrast to adjacent letterforms.

On looking at the numerals 0 through to 9, you will notice that they are, in themselves, simple forms compared to some letters. However, their apparent simplicity needs to be studied carefully because, if not constructed correctly, numerals

Calendar

Because calendars contain so many numbers they provide good practice with numerals. The background design on this calendar was created by drawing simple fish shapes with masking fluid using a metal pen. A watercolour wash was applied over the top, and when this was dry the masking fluid was removed. The lettering and numerals were drawn in different-coloured inks using a smaller metal pen.

Calendars can be put together in many ways. This one consists of twelve pieces of thin card and a thicker backing board held together with a simple wire binding. Most good print and copy shops now offer a variety of binding services that are ideal for such projects.

can look unbalanced, appearing to lean to one side or the other. The 0, 1 and 8, being centrally balanced, do not suffer in this way quite as much as the asymmetric numerals. Two other points worth noting are that the numeral 0 is more condensed in shape than the letter O, and that the 6 and 9 are different forms and not the same form rotated.

Decoration by numbers

Numerals are fun to draw in various calligraphic styles, not just on projects that contain both numbers and letters, but also when they appear on their own. Perhaps a good project to start with is a birthday or New Year card, both of which need only numerals. Having said this, not all friends or family will appreciate having their age written in large numerals on a card, so you could use the day and month of their birthday instead. Other everyday objects, such as clocks, calendars and even playing cards, provide perfect opportunities to experiment with numerals.

Numerals can also be used to create interesting repeat patterns. These can either take the form of rows of repeated or concurrent numbers in groups arranged to form a block, or they can be used in single lines, whichever the project dictates. Repeat patterns can be enhanced by introducing different colours and mediums, and also by contrasts in the scale of the numerals. You could even add expanded and condensed numerals at intermittent places throughout a design. Once again, the possibilities are endless.

Clock

Hand-drawn numerals have been used to enhance a rather plain clock. A piece of card with bleached-out numerals was cut to shape and mounted carefully on the clock.

Gift box and card

A gift box can be re-covered to make it appropriate for a special occasion, or just to improve its appearance. The numerals were drawn in coloured ink on white paper with an automatic pen. The paper was then cut to shape and attached to the gift box with double-sided tape. A matching card or gift tag could be made as well.

Bleaching out

Before using a bleach and water mixture on a final design, it is worth testing the solution on various types of paper because some papers reveal a lighter shade of the original colour, while others do not respond at all. Take care when using bleach. If you splash it on your skin, rinse it off immediately, and clean your pens in water straight after use. Also, do not make the solution too strong as the bleach will continue to affect the paper for a long time.

Old Style Numerals

Height: *4 – 6 nib widths*
Pen angle: *45˚*

Numerals are often neglected, as people concentrate on alphabets. They provide new shapes, however, with which interesting compositions can be created for such items as birthday cards, calendars and posters.

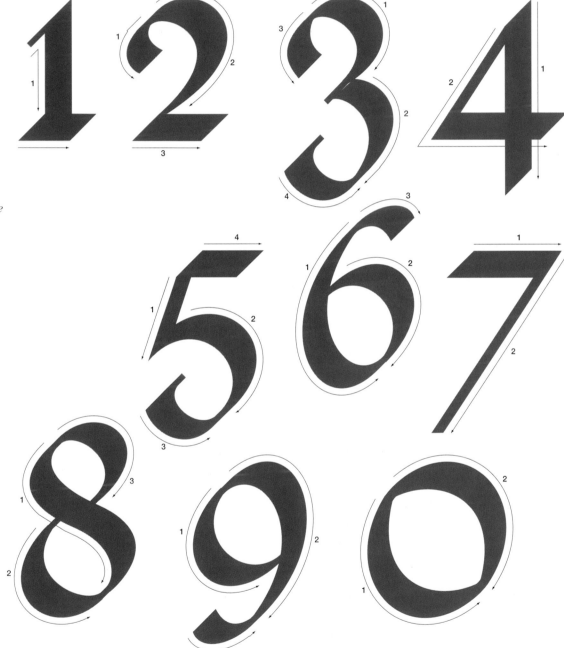

Gothic Numerals

Height: 5½ nib widths

Pen angle: 45°

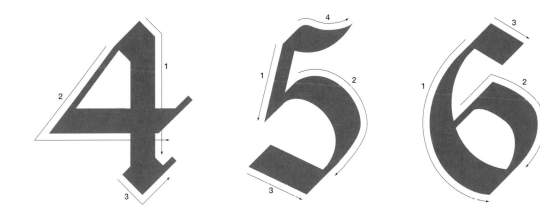

Be more generous when spacing numerals than you would be with letters, in order to retain their elegance and character.

Modern Numerals

Height: *3½ nib widths*
Pen angle: *45°*

These numerals are basic in construction yet make good use of contrasts between thicks and thins.

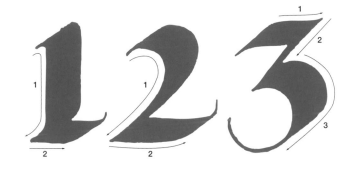

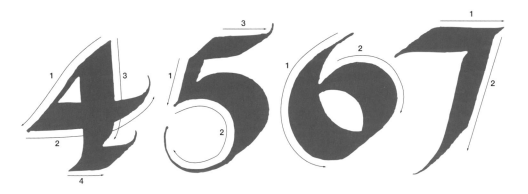

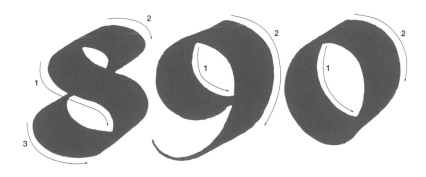

Roman Numerals

Height: *9 nib widths*
Pen angle: *45˚*

These numerals are constructed in the same way as those on page 138.
Take care, when constructing numerals, that they do not appear to be falling over.

1 2 3

4 5 6 7

8 9 0

Numerals

Height: *8 nib widths*
Pen angle: *Variable*

These numerals were drawn with a brush. The constant thickness of the strokes in the 3, 4, 5, 6 and 9 is gained by holding the brush almost vertically to the page and slightly twisting the brush as the strokes are drawn.

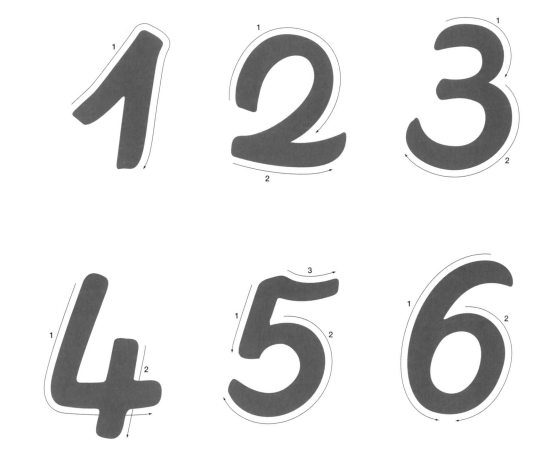

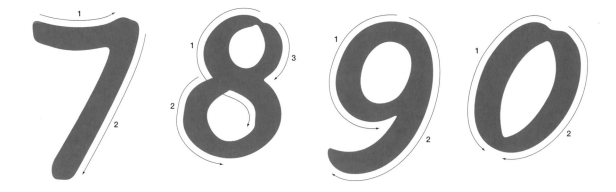

Stylish Numerals

Height: *6 – 9 nib widths*
Pen angle: *45˚*

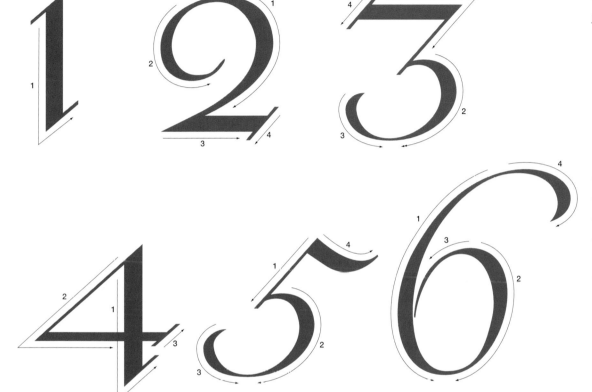

The structure and balance of these elegant numerals is enhanced by the contrast between thicks and thins, as well as the straight lines and extravagant curves.

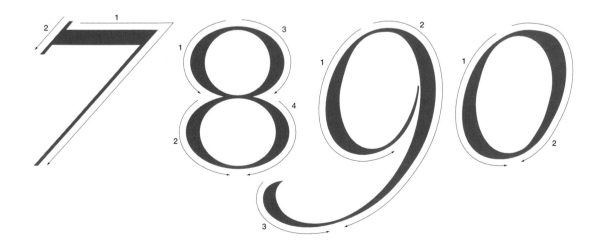

Glossary

Acrylic: Water-based paint that can be used in various consistencies from very thin and transparent to thick and opaque. It dries waterproof.

Arch: Part of a lower-case letter formed by a curve springing from the stem of the letter.

Ascender: The rising stroke of a lower-case letter.

Base line: The line on which the letter sits.

Bleach: Household bleach diluted and used as 'ink' on a coloured background to produce a lighter-coloured, bleached letter.

Bowl: Curved letter stroke that encloses a counter.

Broad-edged pen: Fountain pens with broad-edged nibs are easy to use but they do not offer the fine control of a 'dip' pen. An edged pen can be used to form hairlines.

Capital: Also referred to as majuscule or upper case.

Cross stroke: A horizontal stroke essential to the skeleton form of a letter, such as in A, E, F, T.

Descender: The tail of a lower-case letter that drops below the baseline.

Flourishes: Embellishments of letters or words. The continuance of a terminal stroke, to infill a space (see *swash*).

Gouache: An opaque water-soluble paint, usually available in tubes, which is applied in a similar way to watercolour.

Hairline: Very fine line created by pulling the wet ink from the main stroke of the letter with the corner of the nib.

Justification: Text that aligns on both left and right-hand side. If text is aligned on the left this can be referred to as 'ranged left', with the right 'unjustified' or 'ragged right'. The reverse applies to text ranged on the right-hand side. Alternatives are centred and asymmetrical text.

Lower-case: A small letter, not a capital letter; also called minuscule. The name derives from the time when printers kept the capital letters (majuscule) in the top (upper) typecase and the small minuscule in the lower typecase.

Masking fluid: A rubber-based liquid that can be used with brush, pen, nib or ruling pen. After the required letter shape has been drawn and allowed to dry, colour can be applied over it. When the colour is completely dry, the film can be removed by gentle rubbing, revealing the original surface underneath.

Nib width: A method of assessing the correct proportion of a letter. The body of the letter will be equivalent to a given number of pen widths; the *ascender*, *descender* and the *capitals* having another given number of pen-widths. By this method, all letters written in the same hand retain the same proportions, regardless of their individual size.

Non-waterproof ink: Generally preferred by calligraphers, non-waterproof ink ranges from specially formulated ink for calligraphy to ordinary fountain pen ink. This allows for greater versatility when it is used with water, and some interesting effects can be obtained. It is advisable to check the lightfastness of fountain-pen ink.

Ruling pen: A precision drawing instrument suitable for fine artwork. It is made for ruling straight lines in conjunction with ruler, set square or French curves, and is useful to draw outlines for large, built-up letters. Interesting effects can also be obtained by using the edge of the pen.

Serif: The fine strokes that terminate the main strokes of a letterform: for instance, pen-written letters can have hooked, wedged, *hairline*, club or slab serifs, or no serifs; drawn letters and types have even more variety.

Stem: Vertical stroke of a letter.

Swash: An extension to a single letter for the purpose of ornamentation – as opposed to a flourish, which can be applied to a word or groups of words to fill a vacant space. Works best on letters containing a stroke that can be extended: for example: an A or an R.

Waterproof ink: Most waterproof inks contain shellac which causes a permanent coating on the nib. Brushes and pens should be thoroughly washed after and possibly during use. It may be helpful to dilute this ink with water during use.

X height: Typographic term to describe the height of the main part (or body) of a letter, excluding the *ascenders* and *descenders*.

Index

Acknowledgements

The author would like to thank Corinne Asghar, Jane Donovan, Kate Yeates, Sarah Hoggett and Sara Waterson for their hard work in putting this book together. Special thanks are due to Helen Douglas-Cooper for her patience and advice, and to Mark Gatehouse for his photography.

The author is also indebted to Vicki Cockcroft and Suzi Lyttle for contributing their work. Vicki Cockcroft: pages 104 (right), 105, 117, 126-7, 134, 135. Suzi Lyttle: pages 116, 118, 128-9.

The publishers would like to thank the following companies for providing the merchandise used in the photographs.
Neal Street East, Stuart R. Stevenson, Gilette Stationery Products, Paperchase, Parker Pen (UK) Ltd., Winsor & Newton.

Photographic props
Buckingham Antiques Ltd., Crown Paints, Crucial Trading Ltd., David Mellor, Surfaces, The Chelsea Gardener, The Christmas Tree Shop.

Photographic credits
All photographs in this book were specially taken by Mark Gatehouse for Collins & Brown Limited with the exception of the following: p 26: C. M. Dixon; p 36: Bridgeman Art Library; p 46: By courtesy of the Board of Trustees of the Victoria & Albert Museum, London; p 56: The Master and Fellows of Corpus Christi College, Cambridge, (MS 4 folio 168 r.); p 82: By courtesy of the Board of Trustees of the Victoria & Albert Museum, London, (MS Reid 20); p 92: By courtesy of the Board of Trustees of the Victoria & Albert Museum, London, (MS Reid 66); p 102: By courtesy of the Board of Trustees of the Victoria & Albert Museum, London, (MS L. 1519-1957, folio IV. title page); p 132: Royal Observatory of Belgium, Brussels.

Suppliers
Arthur Brown & Bro., Inc.,
The International Pen Shop
2 West 46th Street, New York, NY 10036
(212) 575-5555,
Toll free: (800) 237-0619

Daniel Smith
4150 First Avenue South, P.O. Box 84268
Seattle, WA 98124-5568
(800) 426-6740

Dick Blick Art Materials
P.O. Box 1267, Galesburg, IL 61402-1267
Toll free: (800) 447-8192

New York Central Art Supply Co.
62 Third Avenue, New York, NY 10003
Store: (212) 473-7705; Order desk: toll free: (800) 950-6111;
or in New York State (212) 477-0400

Pearl Paint
308 Canal Street, New York, NY 10013
In New York State: (212) 431-7932,
Elsewhere, toll free: (800) 221-6845

Sam Flax
12 West 20th Street, New York, NY 10011
(212) 620-3000

Utrecht Art & Drafting Supplies
111 Fourth Avenue, New York, NY 10003
Store: (212) 777-5353,
Phone orders, toll free: (800) 223-9132